VICTORIAN MANCHESTER

THROUGH TIME

Steven Dickens

AMBERLEY

This book is dedicated to the Hallsworth family of Manchester – my maternal ancestors, who for centuries served the inhabitants of the market town and city in business, trade, medicine, politics and education.

First published 2015

Amberley Publishing
The Hill, Stroud, Gloucestershire, GL5 4EP
www.amberley-books.com

Copyright © Steven Dickens, 2015

The right of Steven Dickens to be identified as the
Author of this work has been asserted in accordance with
the Copyrights, Designs and Patents Act 1988.

ISBN 978 1 4456 1509 7 (print)
ISBN 978 1 4456 1518 9 (ebook)

British Library Cataloguing in Publication Data.
A catalogue record for this book is available from the
British Library.

Typesetting by Amberley Publishing.
Printed in Great Britain.

Introduction

The Charter of Incorporation of the Borough of Manchester was granted by Queen Victoria on 23 October 1838. It was Richard Cobden's influence and encouragement that led to Manchester establishing a council elected by the people through its first municipal election. The charter that made Manchester a city quickly followed and was granted on 29 March 1853. In only fifteen years the local power, which had once been concentrated in the hands of neighbouring Salford, now passed to the rapidly growing and progressive economic powerhouse of Manchester. The tools needed to make its legal and political mechanisms function were also quickly deployed. In 1839, Manchester had its own Justice of the Peace and, by 1842, a coat of arms, crest and a motto that read *Concilio et Labore* (By Council and Work). In 1893, Queen Victoria granted her permission for the city to use the title Lord Mayor. Manchester's Victorian heritage can clearly be seen today through its numerous statues, particularly at Piccadilly and Albert Square. Piccadilly is home to *Sir Robert Peel* by Marshall, 1853, *Wellington* by M. Noble, 1856, *Watt* by Theed, 1857, and *Queen Victoria's Memorial* by Onslow Ford, 1901, although, many of these are today shrouded by surrounding trees. At Albert Square, there is *Bishop Fraser* by Thomas Woolner, 1888, *John Bright* by Albert Bruce Joy, 1891, *Oliver Heywood* by Albert Bruce Joy, 1894, a fountain by Thomas Worthington and John Cassidy, 1897, and *Gladstone* by Mario Raggi, 1901.

Manchester's Victorian foundations and industrial history, consisting of cotton mills, affluent warehouse developments and Ancoats, known as the world's first industrial suburb, are also well exemplified through its unique Victorian architecture of substantial red brick and buff sandstone. These developments were encouraged by the location of the city on the banks of the River Irwell, close to the south-west foothills of the Pennines and within 40 miles of the west coast, although these geographical advantages had been realised since the settlement of Mamucium by the Romans. Proximity to the Irwell led to a ready source of water for both domestic and commercial use, as well as a source of power for the cotton mills upon which the bulk of Victorian Manchester's fortune was built. The damp climate was also ideal for the working of cotton, while rivers provided a relatively quick and reliable form of transport compared to the inadequate road system of the early nineteenth century. They also encouraged the development of an extensive system of canals, which culminated in the opening of that great feat of Victorian enterprise and engineering, the Manchester Ship Canal, in 1894.

Cotton mills and canals were not the only long-term developments of the Industrial Revolution to affect Manchester. Scientists like John Dalton (1766–1844), an atomic theorist, enhanced Manchester's reputation. The city also became a focus for heavy engineering after the establishment of the world's first passenger railway station at Liverpool Road. George Stephenson's Liverpool–Manchester Railway became the catalyst for an explosion of railway development in the Victorian era, and Manchester was no exception to this factor. London Road, Victoria, Exchange, Central and Oxford Road railway stations all made Manchester a centre of economic and commercial development, with ease of transport across the country now achievable. Exchange was later demolished, Central is now a conference centre and was the venue of the Labour Party Conference in 2014 and Victoria is undergoing extensive

redevelopment and upgrading. Canals and railways were focused around the Castlefield district – once an industrial hub and now a centre of tourism. Peripheral districts around the city centre, notably Gorton and Ancoats, were now the home of iron foundries, railway engine manufacturers and railway infrastructure producers.

With the rise of chemical industries in the latter part of the nineteenth century, and the establishment and rapid growth of academic institutions, notably the Victoria University of Manchester, innovation and development, coupled with Manchester's entrepreneurial spirit, led to the city gaining a worldwide reputation for the quality of its work in several fields. This reputation attracted people to the city from all over the world, particularly a large Jewish community in the nineteenth century from Eastern Europe and Russia. They located in Cheetham (including some of my own ancestors) and Strangeways, contributing to the success and reputation of Manchester's textile trade. However, this rapid growth also led to a rise in poverty, squalor and unsanitary conditions, caused in the main by overcrowded and substandard housing conditions from as early as the 1780s. Writers like James Kay (*Moral and Physical Conditions of the Working Classes*, 1832) and Edwin Chadwick (*Report on the Sanitary Condition of the Labouring Population*, 1842) highlighted these social inadequacies, as did Friederich Engels with *The Condition of the Working Class in England*, 1844 – not published in Britain until 1892.

Many of the photographs in this selection of Victorian Manchester date from around the end of the nineteenth and early twentieth centuries, particularly those views taken from contemporary postcards. Many are earlier Victorian views that have been recycled at a later date for an Edwardian market. Therefore, despite their later postmark, they are often accurate representations of the Victorian era, which is officially defined as dating from 1837 to 1901. Those with later twentieth-century dates, or references to pre-1837 Manchester, have, in many cases, been used to illustrate how particular subjects have changed (or not) through time, hence there is a balanced mix of subjects throughout this book, which give the reader the opportunity to trace the rise of Manchester from its origins as a Liberal economic force of the nineteenth century to the modern, progressive and cultural centre it has become in the twenty-first century. Finally, there are some modern photographs that have been included as the result of a compromise on their location – notably St Peter's Square, where there is extensive work being undertaken, with a new Metrolink tramline under construction, and St Peter's Cross and the cenotaph relocated. Also, around the cathedral, notably on the site of the former Exchange station, extensive redevelopment work has limited the location of modern photographs. Oxford Road, around the university, Manchester Royal Infirmary and the Whitworth Art Gallery are also closed and are undergoing extensive repair work, with the Whitworth Art Gallery itself being extended and upgraded in order to meet the demands of the twenty-first century. Also, Liverpool Road, where it meets Water Street, is currently closed off, meaning that the former railway station has been photographed from either end. Work is also taking place at the Corporation Street end of Market Street, meaning that modern views of the area covering the old Market Place have been limited by this redevelopment, as well as by reconfiguration after the terrorist bombing of 1996. This means that a certain amount of creative thought has had to go into the modern photographs presented in this book at these locations. However, the result has been a positive one despite these challenges, and I hope that you, the reader, enjoy the result!

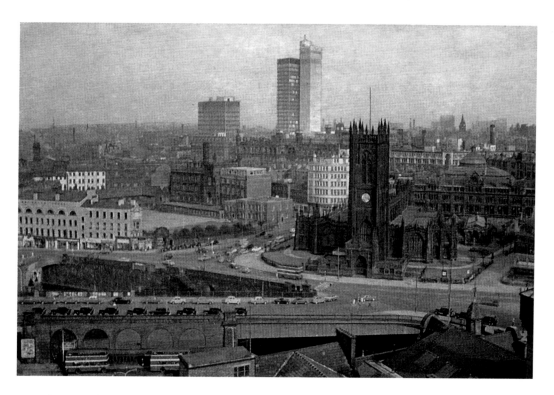

Co-operative Insurance Society Building, Miller Street, *c*. 1962
When the CIS building was completed in 1962, it was the third tallest in Europe and the first building in the city taller than Manchester town hall's tower, built between 1867 and 1877 and visible in the background. Today, the Beetham Tower, built in 2006, is Manchester's tallest. Also shown here are the Corn Exchange, Barton Arcade and Royal Exchange, illustrating the city's Victorian origins against the backdrop of modern Manchester. Green Salford Corporation buses are at the bus station – once the site of shops, a restaurant, stables and a smithy in 1880.

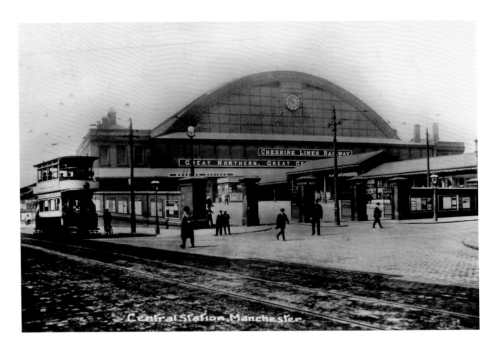

Central Station, Windmill Street, 1902

Manchester's fourth railway terminal and erected between 1875 and 1880, Central Station was the terminus of the Cheshire Lines Committee Railway, whose trains ran between Manchester, Liverpool, Southport and into Cheshire. The original roof had a span of 210 feet, with its highest point 90 feet above the railway. It was initially owned and used jointly by the Great Northern, Midland & Manchester, Sheffield & Lincolnshire railways. Central station finally closed in May 1969, eventually becoming a car park. It is now an exhibition and conference centre.

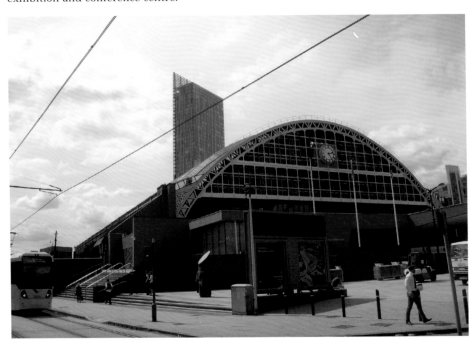

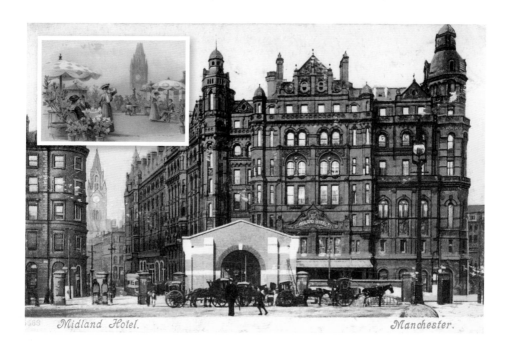

Midland Hotel from Windmill Street and Roof Garden, 1903
The ground floor of the Midland Hotel is built of pink granite from Peterhead interlaced with bands of darker Shap granite. The upper floors are brick built and faced with Burmantofts terracotta. Glazed terracotta is extensively used for some very opulent decoration throughout the exterior of the hotel, which also boasted a roof garden (*inset*). Despite the decline of the railway age, and the severing of railway connections with the closure of Central station in 1969, the Midland remains one of Manchester's premier hotels.

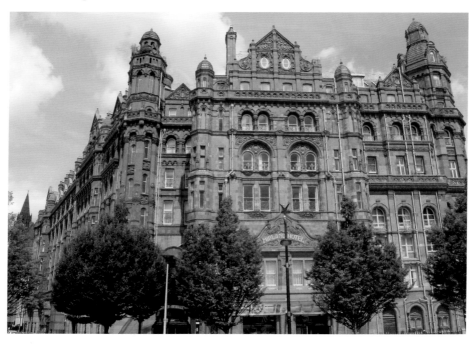

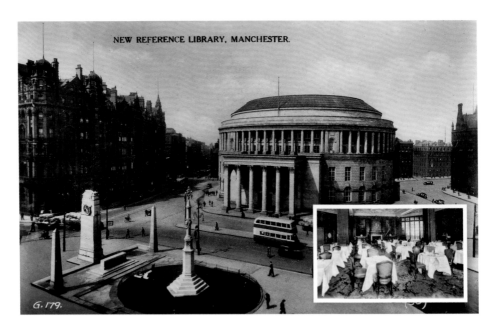

NEW REFERENCE LIBRARY, MANCHESTER.

G.179.

Midland Hotel and Coffee Room, *c.* 1903, and New Reference Library, St Peter's Square, *c.* 1934

The Midland Hotel stands at the south end of St Peter's Square and was built by the Midland Railway at the northern terminus of their London line to the St Pancras Hotel. Designed by the architect Charles Trubshaw, construction began in 1898 and it was completed in 1903. Included in its design was a covered walkway from Central station to the Windmill Street entrance. There is a plaque in the entrance hall of the hotel to commemorate the first meeting between Henry Royce and Charles Stewart Rolls in 1904.

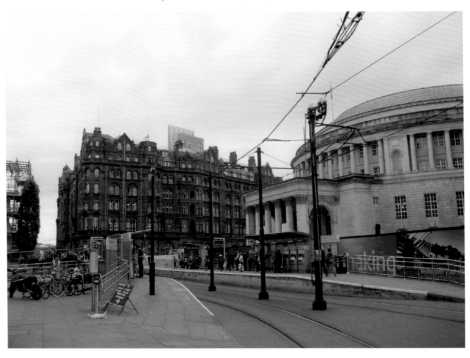

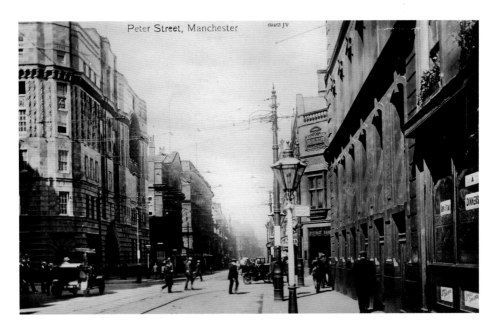

Peter Street, Manchester

Peter Street and the Theatre Royal (*centre left*), 1914

Opened on 29 September 1845, the Theatre Royal, adjacent to the Free Trade Hall, was commissioned by local businessman John Knowles. It operated as a theatre until 1921 and has also been a nightclub, bingo hall and cinema. Located opposite the now demolished Gaiety (Comedy) Theatre, both theatres enhanced Peter Street's reputation as a centre of entertainment, as did the nearby Opera House – built in 1912 on Quay Street (*inset*). Designed by Irwin & Chester, the interior was remodelled by Edward Salomons and John Ely around the 1870s.

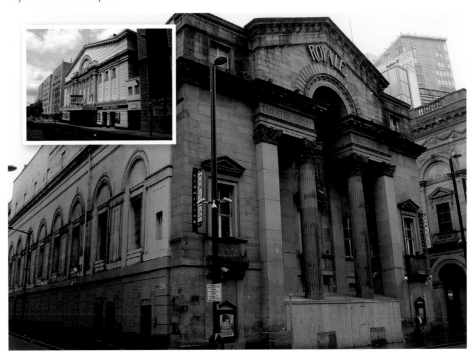

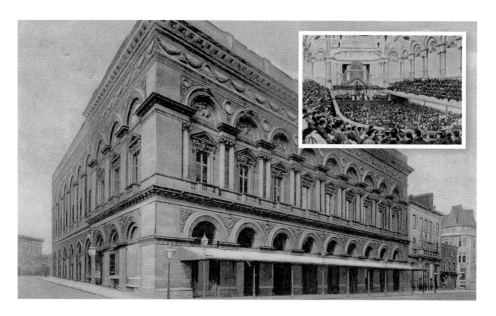

The Free Trade Hall, Peter Street, 1895, and Interior, 1894
Now a hotel and restaurant, the Anti-Corn Law League, famous musicians, rock and pop bands and the Halle Orchestra have all used this site as their home in the course of its history. Constructed in the Palazzo style, it was originally built in 1853–56 by Edward Walters. The interior comprised the Large Hall, the Lesser Hall, Promenade and Lounge. However, on 22 December 1940, bombs destroyed everything except two outer walls. The hall was reconstructed by city architect Leonard C. Howitt, eventually reopening in 1951.

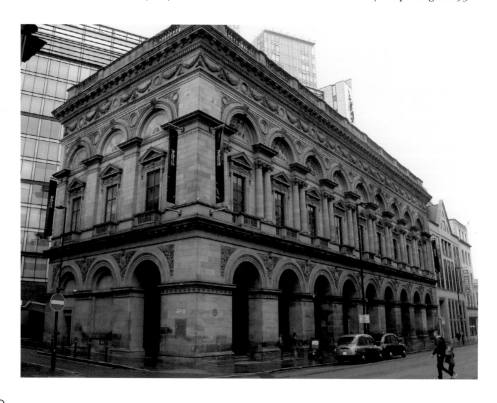

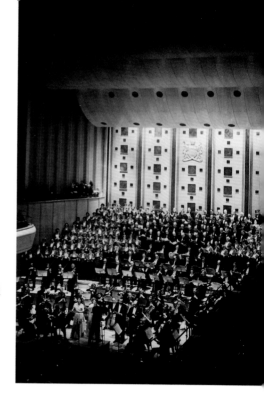

Halle Orchestra at the Free Trade Hall, 1858–1996, and Bridgewater Hall, Lower Mosley Street, 2014

Britain's first fully professional symphony orchestra was founded by the German-born pianist and conductor Sir Charles Halle. Concerts were performed at the Art Treasures Exhibition, Botanical Gardens, Old Trafford in May–October 1857. When the exhibition closed, Halle continued the concerts at his own expense, with the first held at the Free Trade Hall on 30 January 1858. Halle managed the concerts until his death in 1895. The Halle's last concert at the Free Trade Hall, before relocating to the Bridgewater Hall, was 30 June 1996.

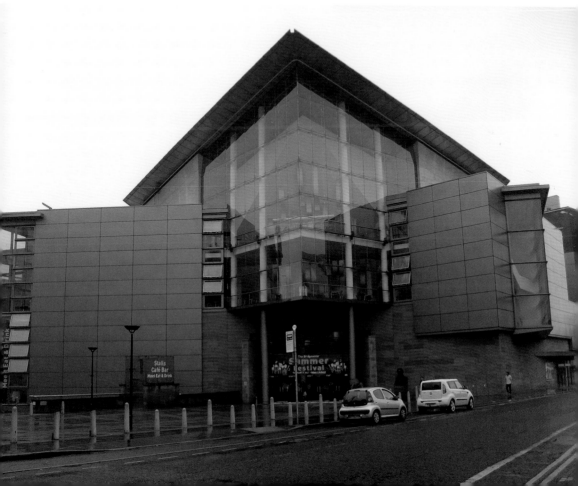

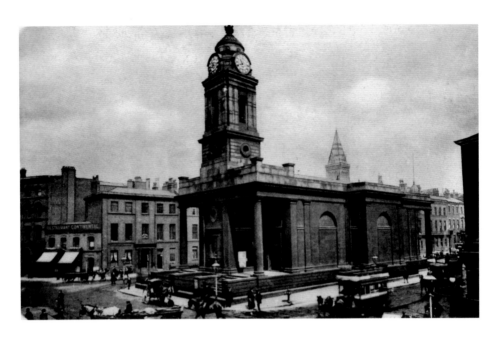

St Peter's Church, Junction of Mosley Street and Oxford Street, 1890

The church was built by James Wyatt (1788–94), and demolished in 1907 (*inset*) due to declining church attendance. A Portland stone cross, by Temple Moore, was erected to mark the location of the church in 1908. St Peter's closure was not without controversy, with transcripts of memorial inscriptions having to be recorded and the corporation being compelled to cover and protect all the graves. Land was to be used only for widening adjoining streets or as an open space. Today, work is being undertaken on a new Metrolink tramline.

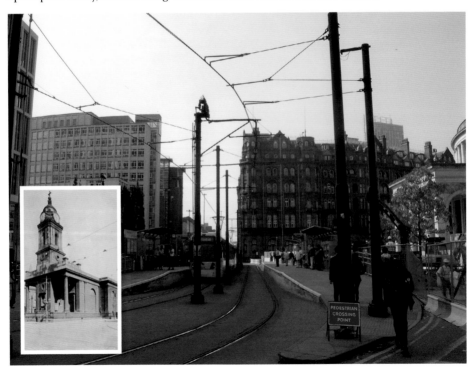

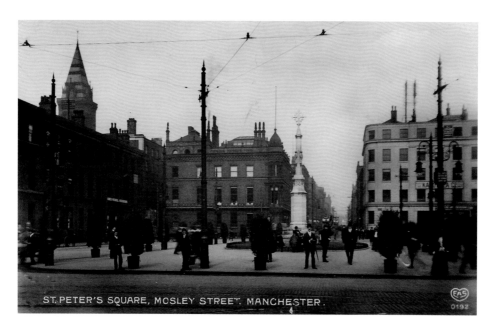

ST.PETER'S SQUARE, MOSLEY STREET. MANCHESTER.

Former Site of St Peter's Church, St Peter's Square, Mosley Street, 1908
Built on a site which was then at the edge of the town centre, it was close to Peter Street and the Free Trade Hall – site of the Peterloo Massacre in 1819. The church suffered from a decline in local population as the nineteenth century progressed and the increasingly affluent Victorian middle classes departed for the suburbs. It was not, as is sometimes assumed, demolished because it created a 'bottleneck' for traffic passing the church between Mosley Street and Lower Mosley Street.

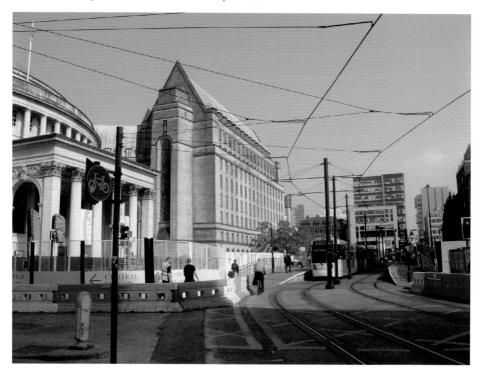

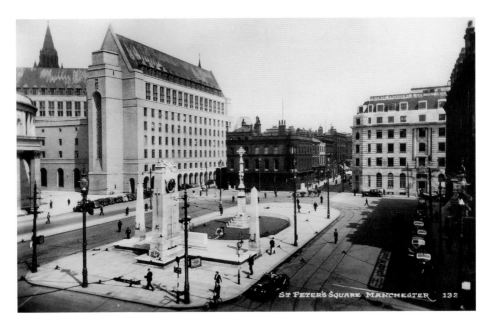

St Peter's Square, Former Site of St Peter's Church, c. 1938

In the eighteenth century, this area was an open field, with the square created at the same time St Peter's church was demolished. Later still, from 1930 until 1934, Central Library was constructed, with the town hall extension constructed between 1934 and 1938. Both buildings replaced a Victorian three-storey terrace used for business purposes but initially constructed as private residences. Today, Central Library has been completely refurbished with state-of-the-art multimedia technology. Work will also see the cenotaph relocated to Cooper Street.

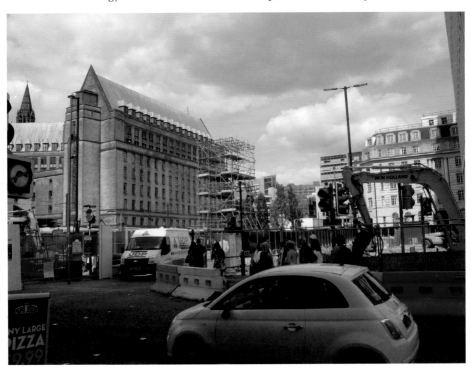

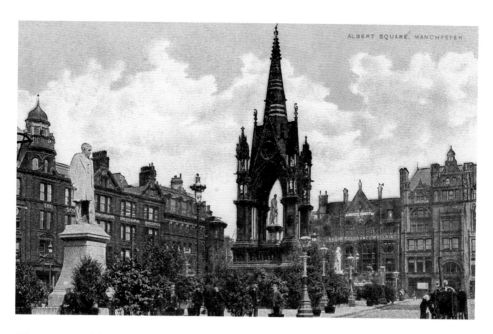

Albert Memorial and Albert Square, 1897

Albert Square's largest monument is the Albert Memorial, commemorating the Prince Consort who died of typhoid in 1861. The memorial was designed by Thomas Worthington in 1862. He was one of Manchester's most renowned Victorian architects, with other notable works in the city including the Crown Court at Minshull Street, 1867–73 (*inset below*) and Nicholl's Hospital, 1879–80. The Albert Memorial statue is the work of Matthew Noble (1862) with the marble figure of Albert placed on a high base under a large Gothic canopy.

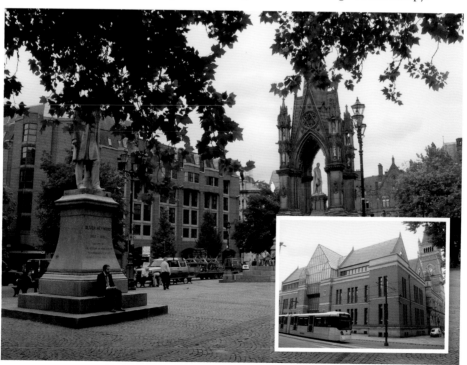

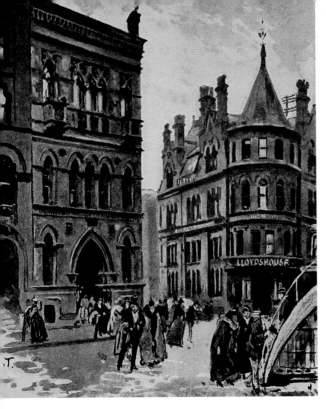

Albert Square Memorial Hall (*centre*), 1894, Lloyd's House (*right*), 1894, and Statue of Gladstone, 1901

The memorial hall is considered to be one of the best examples of Venetian Gothic Revival architecture in the United Kingdom and was constructed by Thomas Worthington (1863–66) for a price of £10,000. It was commissioned by the Unitarian Home Missionary Board to commemorate the ejection of ministers from the Church of England for refusing to submit to the Oath of Conformity. Used for religious instruction, it has been a coffee house, public house and nightclub. Today it is a restaurant.

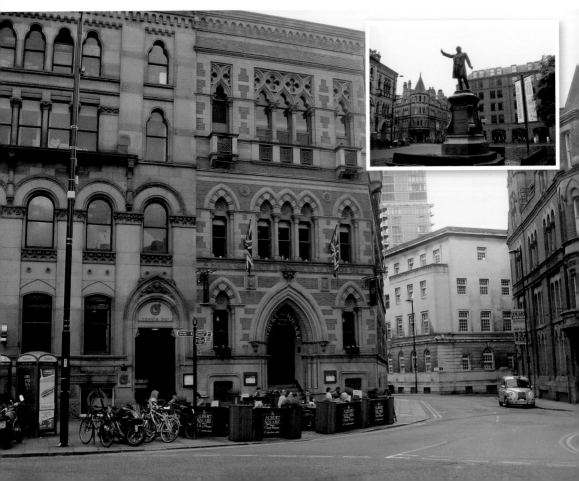

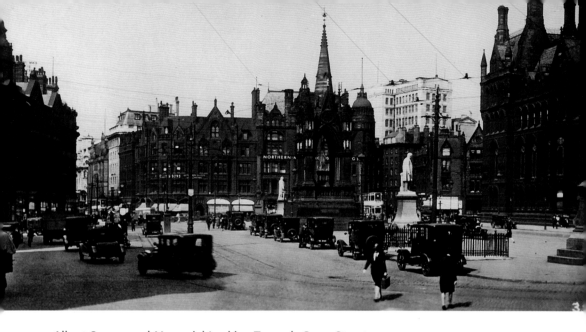

Albert Square and Memorial Looking Towards Cross Street, 1931

Albert Square was laid out to provide a space for the Prince Consort's memorial, replacing derelict land and dense housing near the town yard and River Tib – named Longworth's Folly. The triangular shape of the square originated from eighteenth-century field boundaries. It included several notable buildings: Lloyd's House by Speakman & Charlesworth, 1868; the Scottish Widows Fund Life Assurance Society by G. T. Redmayne, 1872; Carlton House by Clegg & Knowles, 1872; Albert Chambers, 1873; and offices and shops by Pennington & Bridgen, 1877.

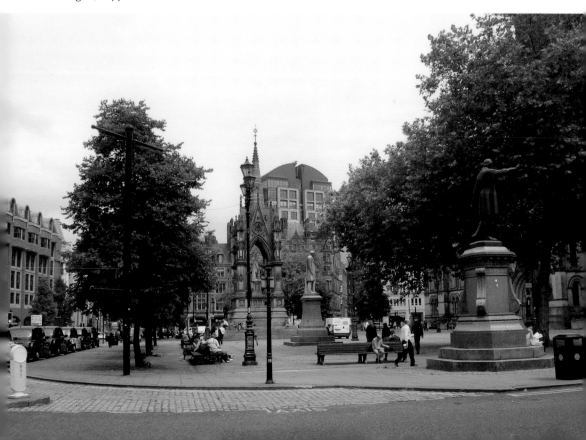

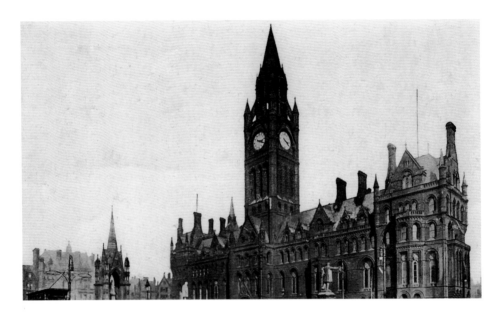

Manchester Town Hall, Albert Square, c. 1910

Albert Square is overlooked by the town hall, which is brick built, faced in sandstone and Gothic in style. The architect was Alfred Waterhouse who was also associated with Strangeways Prison (1866–68) and the Refuge Assurance Company building (1891–95). Construction began in 1867 and took nine years to complete. The imposing clock tower is 286 feet high and features an unusual octagonal upper stage. Other features include a vaulted entrance hall, a grand staircase leading into the building and the Great Hall on the ground floor.

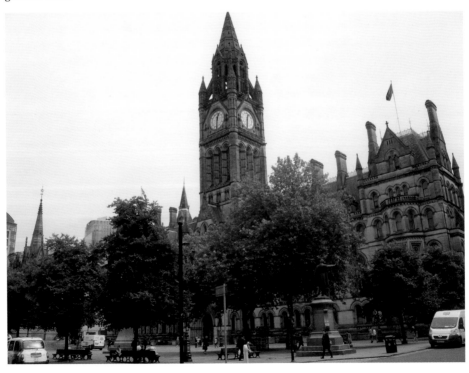

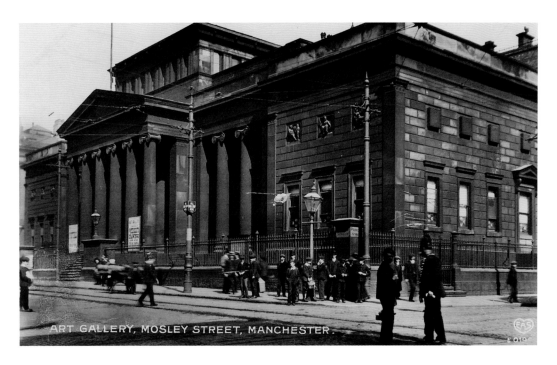

ART GALLERY, MOSLEY STREET, MANCHESTER.

Manchester Art Gallery, Mosley Street, 1905

The City Art Gallery was built by Sir Charles Barry for the Royal Institution of Manchester, 1824–35. Ionic columns mirror those of the nearby former Portico Library by Thomas Harrison (1802–06). The gallery is synonymous with Victorian Manchester and is one of its iconic buildings. The wealth that cotton and industry brought to the rapidly growing metropolis of Manchester was invested in the art collections of the Victorian era, many of which remain in the gallery today.

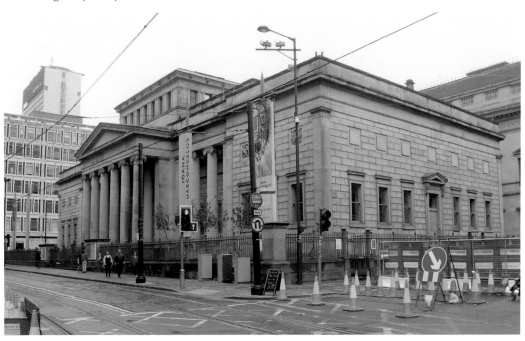

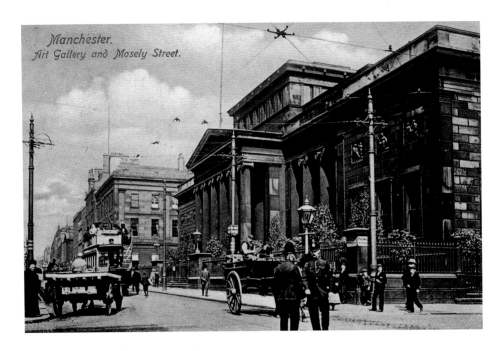

Manchester Art Gallery, Mosley Street, 1903

The City Art Gallery is a Grecian style building featuring a portico of six Ionic columns, including a pediment. The entrance and staircase hall are also equally imposing. The gallery is located at the junction of Mosley Street and Princess Street. Barry also designed the adjacent Athenaeum (*inset below*), dating from 1836/37. It retains a portal with Tuscan columns and windows with pediments. Now part of the art gallery, the Manchester Athenaeum Society met here for the 'advancement and diffusion of knowledge'.

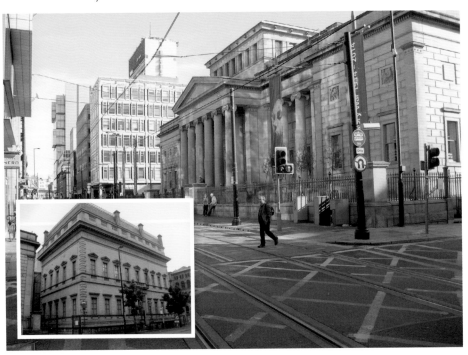

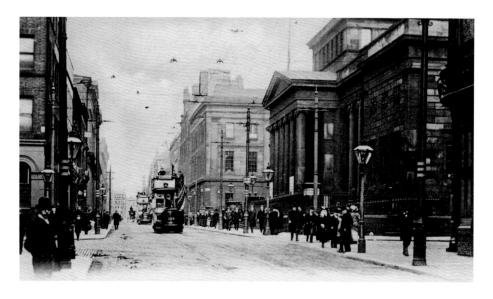

Mosley Street, Looking Towards Piccadilly, 1904

The building on York Street junction (*left*) was the headquarters of Williams Deacon's Bank (*inset*), constructed in 1862 by Edward Walters, designer of the Free Trade Hall and extended by Barker & Ellis *c.* 1880s. One notable employee, *c.* 1875–1918, was local historian David Herbert Langton, son of artist, engraver and Charles Dickens biographer, Robert Langton. David published *A History of Flixton, Urmston and Davyhulme* in 1898, becoming chief cashier of the bank, a member of Manchester Literary Club and the Lancashire and Cheshire Antiquarian Society.

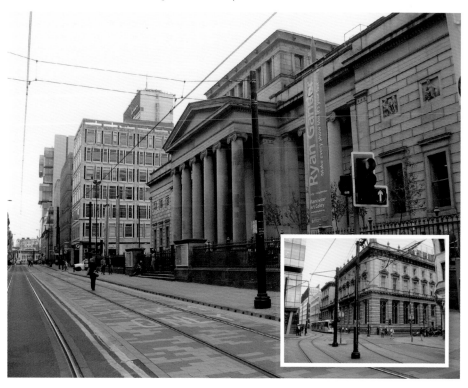

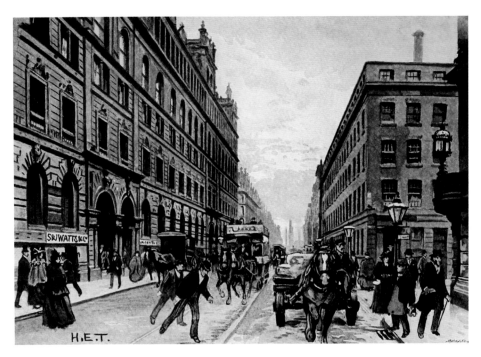

Warehouse of Messrs Watts & Co., Portland Street from Piccadilly, 1894

Messrs Watts & Co. is now home to the Britannia Hotel and was built in 1851–56 by Travis & Mangnall. It is 300 feet long by 100 feet high. Occupants S. & J. Watts owned the largest wholesale drapery business in Manchester. The now demolished Queens Hotel opposite, at the junction with Piccadilly, was built in 1845 as William Houldsworth's private residence, later converted and extended. He was a textile merchant with a factory on Little Lever Street. Visitors included reigning monarchs, nobility, Charles Dickens and William Thackeray.

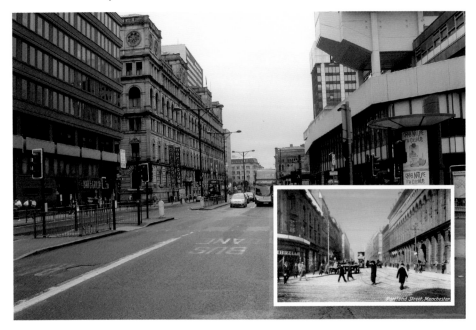

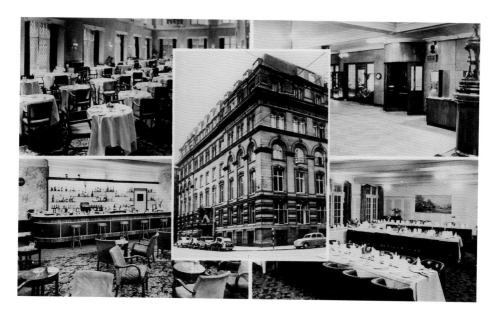

The Grand Hotel, Aytoun Street, c. 1950

The Grand Hotel was originally built as a cotton warehouse by Mills & Murgatroyd in 1867/68 for A. Collie & Co. In 1883, it was converted into a hotel by Mills & Murgatroyd, remaining so for over 100 years. In 2000, it was converted into flats and acquired two extra storeys at the same time. Aytoun Street was named after an army officer called Roger Aytoun who came to Manchester from Scotland and married a local heiress named Barbara Minshull in 1769.

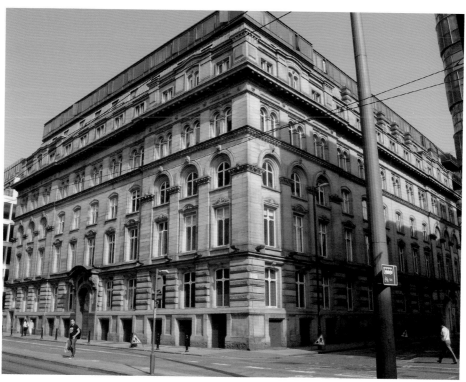

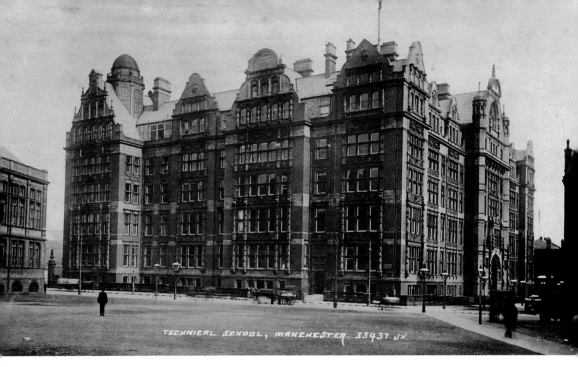

Technical School, Manchester. 33931. JV.

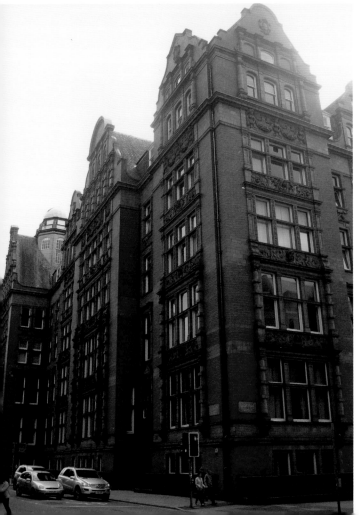

Technical School, Junction of Whitworth Street and Sackville Street, *c.* 1902
The Technical School was established as a successor to the Mechanics Institute. The Manchester Institute of Science and Technology, later the University of Manchester Institute of Science and Technology (UMIST), then a University of Manchester building from 2004, dominates Whitworth Street. Built for the Municipal School of Technology, the front features a gabled gatehouse-type entrance and was designed by Spalding & Cross, 1895–1902. The dome on the Whitworth Street side was an observatory – the gift of Frances Godlee.

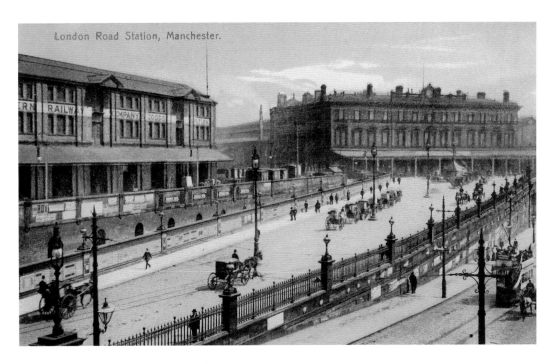

London Road Station, Manchester.

London Road Railway Station, London Road, 1903
London Road station originally serviced the Manchester & Birmingham Railway and the Sheffield, Ashton-Under-Lyne & Manchester Railway. The name 'Piccadilly' was not introduced until 1960. Today, it remains one of the three main Manchester stations, with routes to London, Glasgow, Edinburgh, Birmingham, Cardiff and Norwich. It is now also a terminus for the Metrolink tram, with a connecting route to Manchester's other main line station, Victoria, at Hunt's Bank – the first time the two have been directly linked.

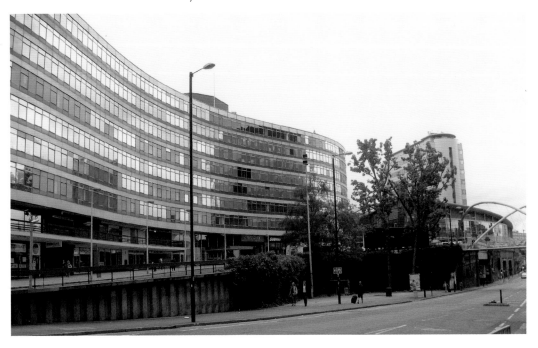

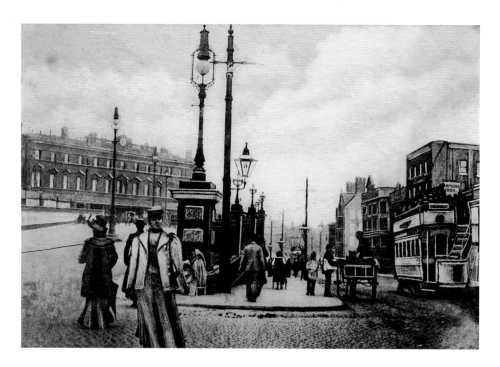

London Road and London Road Railway Station, 1904

The Manchester–Birmingham Railway line was completed in 1839, with the first London Road station opening in 1842. It was built as the LNWR's terminus for trains from London, reducing the 24-hour coach journey to 12 hours by train. In 1866, the former Store Street station was replaced by the Mills & Murgatroyd building, which dominated the station approach until 1967. Further extensions in 1880–83 saw adjacent land used for constructing huge goods sheds and warehouses, as the Victorian railway infrastructure rapidly expanded. Also shown is the Manchester Curve Footbridge, opened 2007.

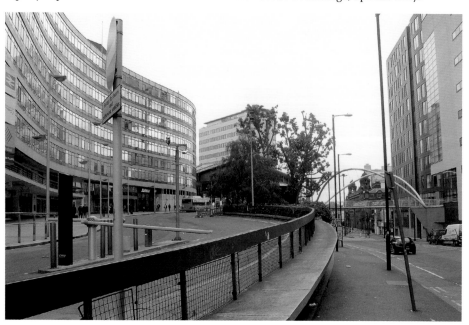

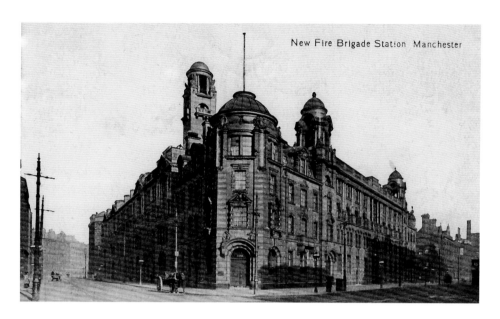

London Road Fire Station, 1909

In 1899, George Parker was appointed Manchester's fire chief and began designing a quality headquarters that was completed by Woodhouse, Willoughby & Langham in 1901–06. It was four storeys high, had a large central courtyard, housed brigade headquarters, a police station, ambulance station, gas meter testing station, coroner's court, branch bank and had accommodation for the fire chief, deputy and thirty-two firemen's families. It cost £142,000 and closed in 1986 – it remains empty. It is now owned, controversially, by a hotel chain, is Grade II listed and is considered to be 'at risk'.

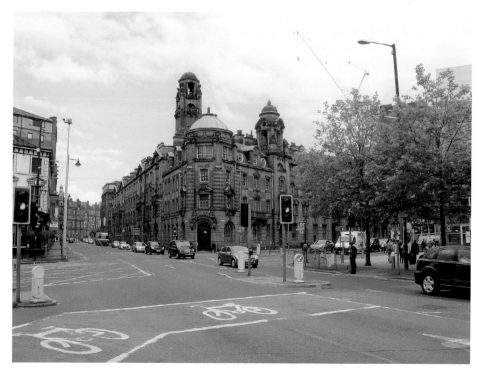

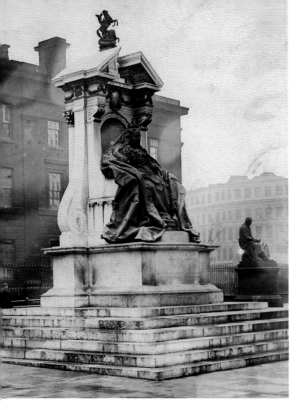

Queen Victoria's Statue, Piccadilly, 1901
Onslow Ford was commissioned to design
the statue, which was originally to be
constructed using marble. Allegedly,
on sitting for the artist, Queen Victoria
felt that a marble statue would not
weather well in the smoky atmosphere
of Manchester, so bronze was used
instead. Unfortunately, the statue was
not completed until 1901 – after Queen
Victoria's death. The unveiling that same
year was performed by Lord Roberts. The
event was badly organised, with the statue
itself initially attracting some poor reviews.

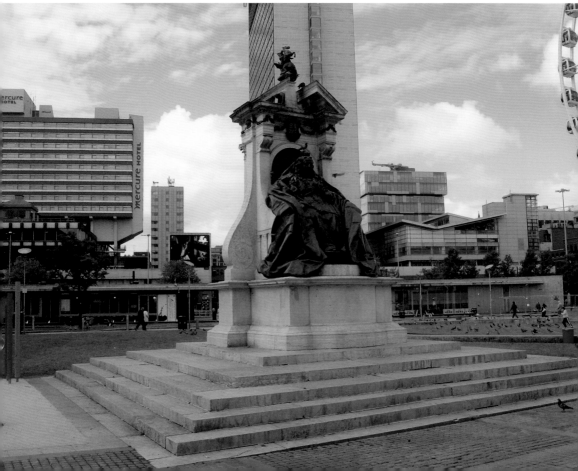

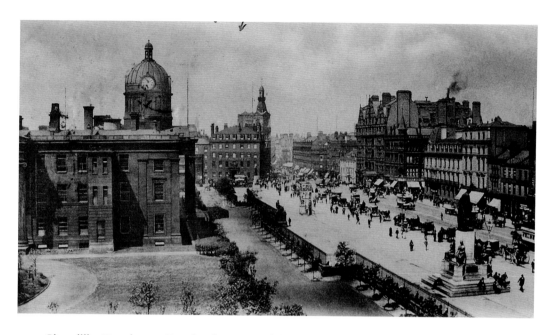

Piccadilly, Manchester Royal Infirmary and the Royal Hotel, Mosley/Market Street, 1900
Royal Buildings is the site of the former Royal Hotel – a royal mail coach inn where the Football League was founded on 17 April 1888. It was also the first booking office for the Liverpool & Manchester Railway and was demolished *c.* 1910 to make way for an extension to Lewis's store. The infirmary building (*c.* 1775) was blackened by air pollution. After its demolition (*inset*), there were plans to replace it with an art gallery. Piccadilly is currently dominated by the Wheel of Manchester.

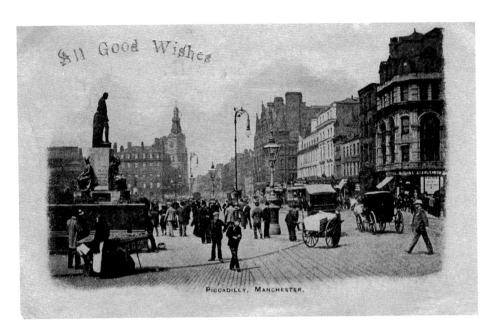

Piccadilly and Wellington's Statue, Looking Towards Market Street, 1900
Arthur Wesley, the Duke of Wellington, achieved fame by defeating Napoleon at Waterloo. He became Prime Minister in 1827 and died in 1852 with his statue by Noble erected in 1856. The statue shows Wellington addressing the House of Lords. Lewis's department store tower is centre and opposite, at the junction of Piccadilly and Tib Street, is a building designed by James Lynde in 1879 (*inset*). The block to Oldham Street was dominated by two hotels – the White Bear built in the 1780s and the Mosley Arms built in the 1820s.

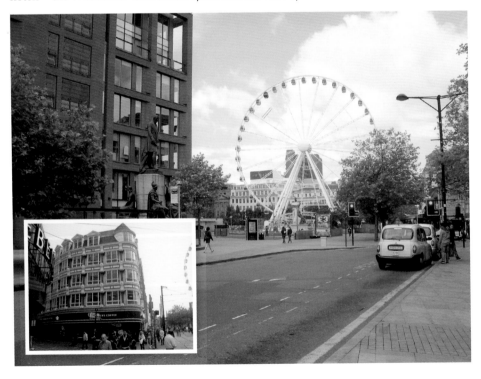

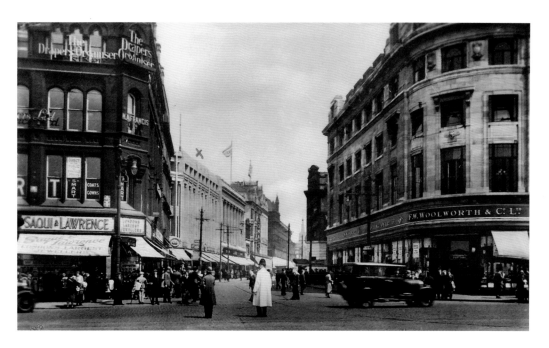

Royle & Bennett's Building, Oldham Street Junction with Piccadilly, *c.* 1930

Royle & Bennett's building of 1881 (*left*), at the junction of Oldham Street and Piccadilly, is Italianate in style and is now the branch of a building society. In the 1880s, the building consisted of offices at ground floor level and a warehouse on the upper floors, which was not an unusual arrangement for Victorian buildings in Manchester. In 1930, it was a Saqui and Lawrence jewellery shop. The same block contained the White Bear, demolished in 1910, and the Mosley Arms, demolished in 1922.

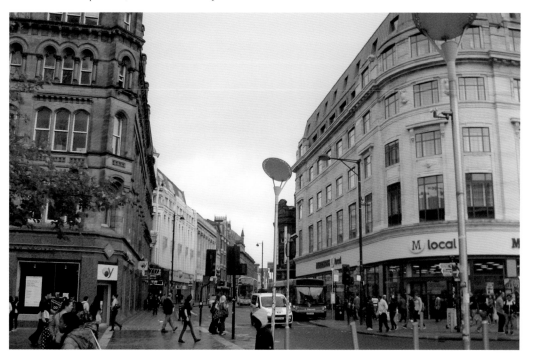

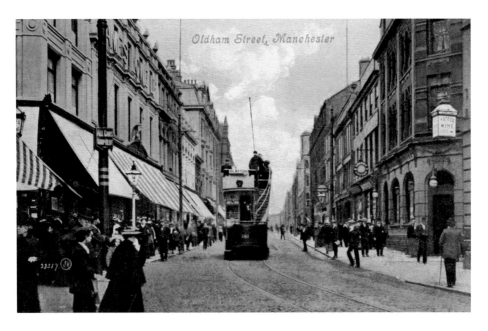

Oldham Street, from Piccadilly, *c.* 1905

Until the 1850s, the area around Piccadilly was the medical centre of Manchester, with a medical school on Pine Street and a House of Recovery on Aytoun Street (1796–1855) for infectious diseases. At No. 77 Oldham Street was the surgery of my ancestor, Doctor John Thornley, who studied and practiced medicine at Manchester Royal Infirmary in the early 1800s. He was unjustly criticised by Mrs G. Linnaeus Banks, author of *The Manchester Man* and formerly of No. 10 Oldham Street, for treatment given to her father.

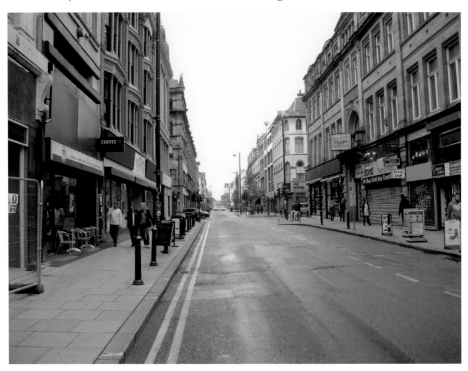

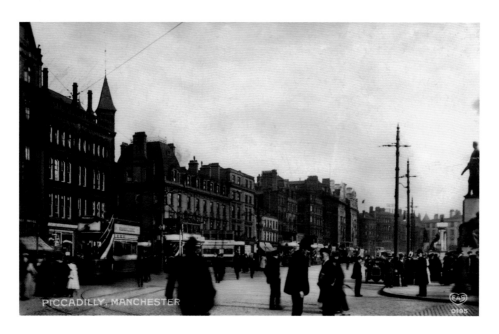

Piccadilly and the Albion Hotel (*Centre*) Looking Towards London Road, *c.* 1910
Between Oldham Street and Lever Street was the Albion Hotel (1815), well known in the Victorian era for its cuisine. It was replaced in 1928 by a Woolworth's store, which was tragically gutted by fire in 1979 (*inset below*). Grade II listed buildings between Lever Street and Newton Street begin with a brick and stone construction in 1892, designed by W. & G. Higginbottom who also designed two stone arched entrances at Back Piccadilly in 1904 and 1907. St Margaret's Chambers (1889) and Clayton House (*c.* 1890) are on the corner of Newton Street.

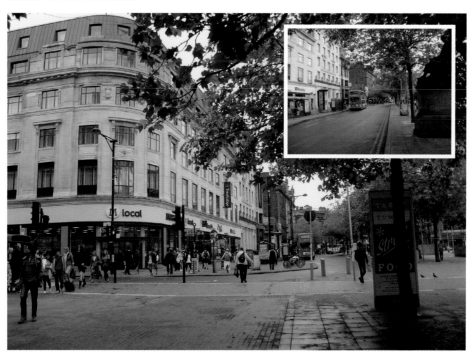

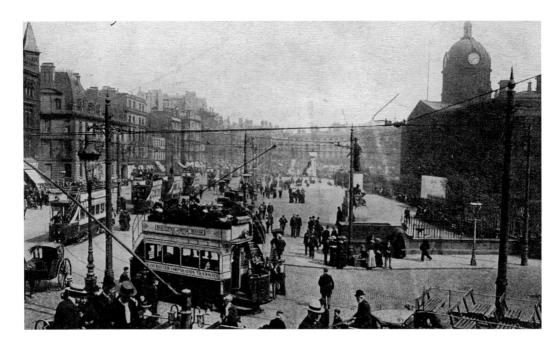

Piccadilly and Manchester Royal Infirmary, *c.* 1903

Manchester Infirmary ('Royal' after 1830), was founded in 1752 by a local merchant named Joseph Bancroft and a Manchester doctor named Charles White, who also established St Mary's Hospital, *c.* 1790. The first hospital was located at Shudehill and moved to its new location and larger premises at Piccadilly, opening on 9 June 1755. The land for the new infirmary was donated by Lord of the Manor, Sir Oswald Mosley, and was known at this time as the Daub Holes as it was being utilised for a clay pit.

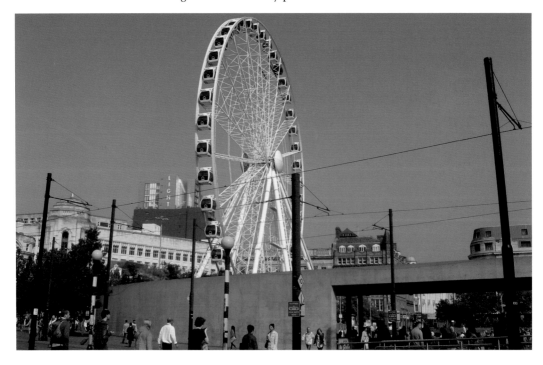

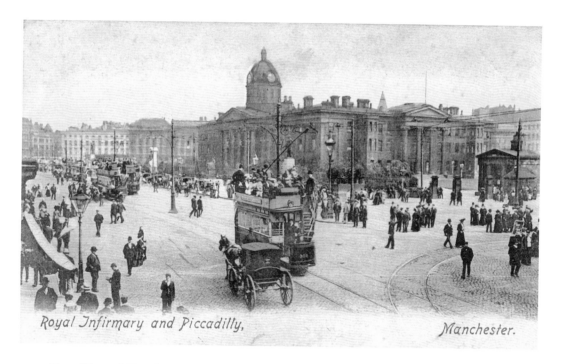

Royal Infirmary and Piccadilly, Manchester.

Piccadilly and Manchester Royal Infirmary, 1903

In 1844, the 'lunatic asylum' infirmary, outpatients and public baths were separated from Piccadilly by a formalised lake. This lake was eventually replaced by a wide promenade, designed by Joseph Paxton and constructed in 1854. It was meant for the display of a number of important statues, most of which remain today, and became known as the 'Infirmary Flags'. The present Manchester Royal Infirmary was opened in 1908 on Oxford Road, with the original building in Piccadilly demolished in 1909 and replaced by Piccadilly Gardens.

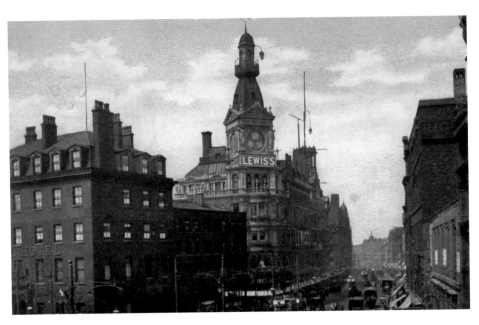

Lewis's Department Store, the Royal Hotel and Market Street, 1906

In 1889, Lewis's store boasted nine floors of business, and was one of the first retail concerns to mass advertise in local newspapers openly stating prices. 'Cash only' was the main principle in an era of credit and, although many were sceptical, the general public readily took to this new retail concept. David Lewis and contemporary entrepreneur John Rylands were both successful businessmen who put a great deal of their wealth back into the community and local charities, often anonymously.

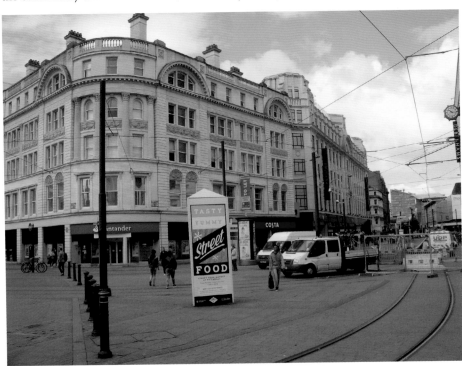

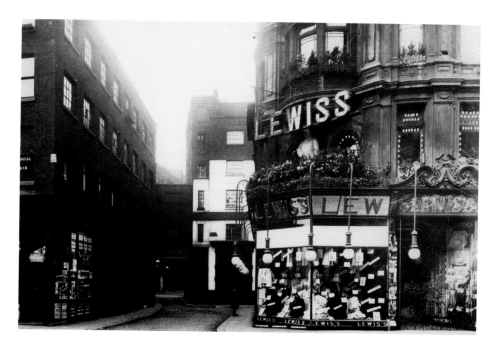

Lewis's Department Store, Market Street, 1900
The store was located opposite Ryland's warehouse, now Debenhams, at the Piccadilly end of Market Street. The tower, complete with clock and a chime of bells, has now been demolished. David Lewis expanded his business outside Liverpool and opened on Market Street, in *c.* 1877. The building was replaced in 1915 and extended in 1929. The company went into administration in 1991, with the Manchester store finally closing in 2001. Today the premises are occupied by another well-known retail clothing company (*inset*).

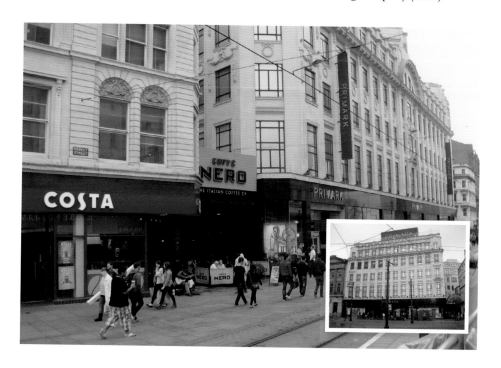

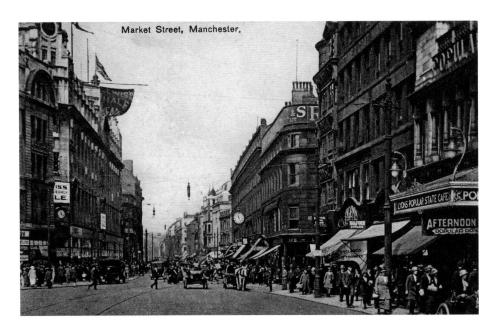

Market Street, from Piccadilly, *c*. 1920 and Arndale Centre Interior, *c*. 1978
Beyond Lewis's department store, on the left, are some late nineteenth and early twentieth-century commercial buildings, with one of particular note at No. 70, *c*. 1825. It was built as a bank to challenge the economic influence of the long-gone Cunliffe and Brooks Bank (1824), which stood nearby. On the right, beyond Ryland's warehouse, the commercial and retail buildings shown have now been replaced by the Arndale Centre, designed by Wilson and Womersley in 1972–1980 (*inset below*), and covering a 15-acre site.

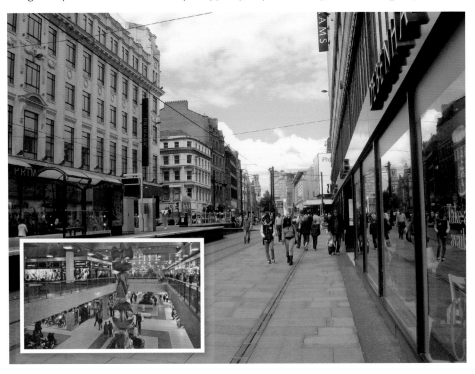

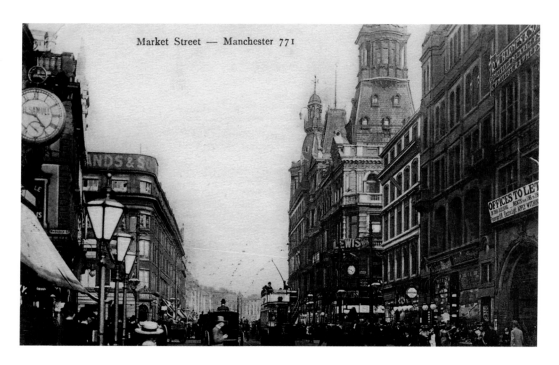

Market Street — Manchester 771

Market Street, Looking Towards Piccadilly, c. 1902

H. Samuels, whose clock is above their shop front on the left, Rylands warehouse and Lewis's department store opposite were well established on this site at the Piccadilly end of Market Street by the mid-1880s. David Lewis and John Rylands were two of the most successful names in Manchester commerce. The Rylands warehouse was rebuilt in 1932 as Rylands Building – at the time the largest wholesale textile warehouse in Manchester, with the building later becoming Paulden's department store and then Debenhams.

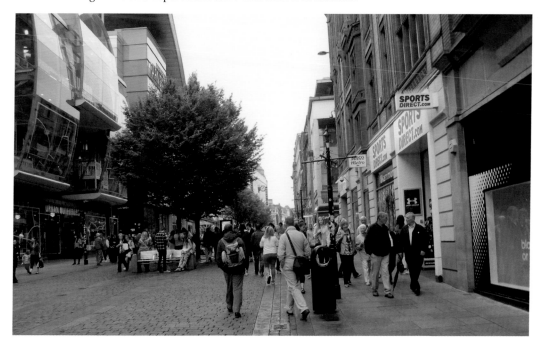

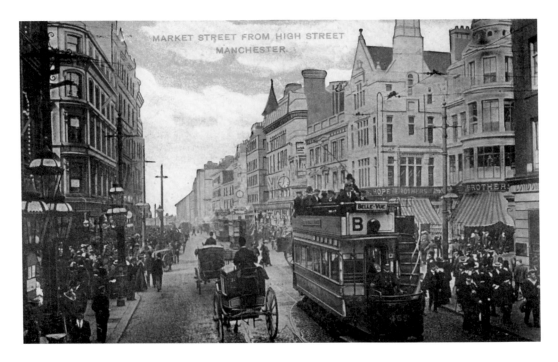

Market Street from High Street, 1904

The town began to grow in the late Georgian era and, by the time of the major mid-nineteenth-century Victorian expansion, nearly all of the old gabled timber and plaster houses characteristic of pre-industrial Manchester had been demolished. Most were constructed in the seventeenth century, with some later eighteenth-century brick buildings. The first road widening took place in 1822, with the footpath in many cases less than 3 feet wide and paved with stones, like the roadway.

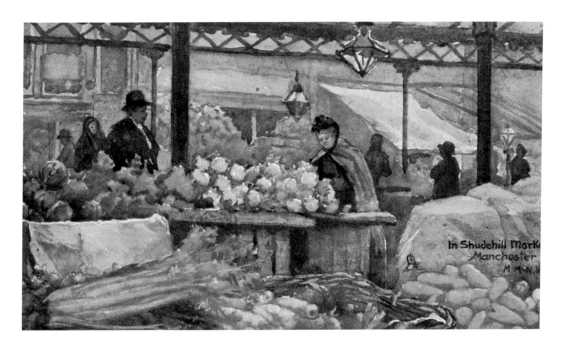

Shudehill (Smithfield) Market, 1900, and Former Wholesale Fish Market, 2014

Most market buildings are now gone, but some fragments remain and have been incorporated into modern retail and housing redevelopments. The wholesale fish market constructed by Speakman, Son & Hickson in 1873 is now part of a new residential complex. The outside walls and gates by Hodkinson, Poynton & Lester, friezes by Joseph Bonehill, and some wrought-iron internal columns have survived (*inset*). The market offices on Thomas Street by Travis & Mangnall were built in 1877 and are now a popular café.

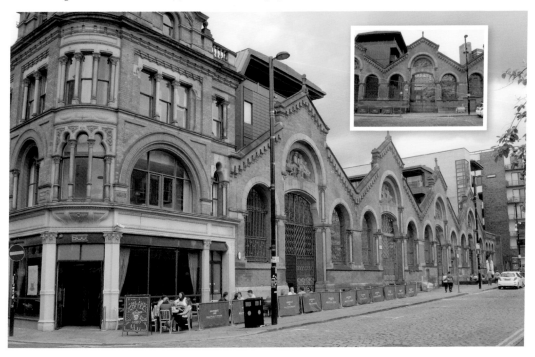

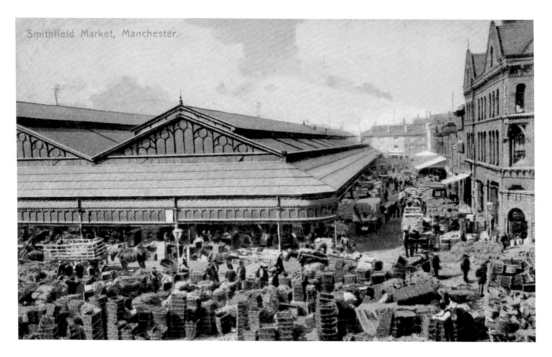

Smithfield Market, Manchester.

Smithfield Market from Oak Street, 1900

Smithfield Market began to develop in the late eighteenth century. Fruit, vegetables, meat and fish were sold on a wholesale and retail scale. At its peak around 1900, it was probably the largest market complex in Britain, covering 7 acres. None of the remaining market buildings are used for their original purpose today, with the wholesale trade now operating from a site outside the city centre. Market rights for the whole city were purchased by the corporation from Sir Oswald Mosley in 1845.

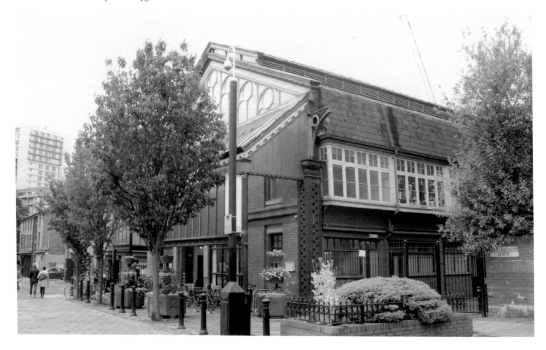

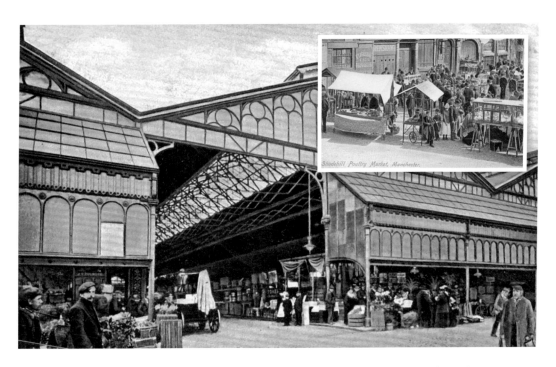

Shudehill (Smithfield) Market, 1900, and Interior of Former Wholesale Fish Market, 2014
The building of the large covered market began around 1854 and included the sale of birds (*inset*) and other livestock. The establishment of trade in this area attracted other influential entrepreneurs to the Smithfield district. These included John Rylands, John Owens, Robert Affleck, John Brown and Sir William Fairbairn. Today, a craft village occupies part of the retail fish market site, with part of the Smithfield covered market being converted for residential occupation, both projects completed by Manchester City Council.

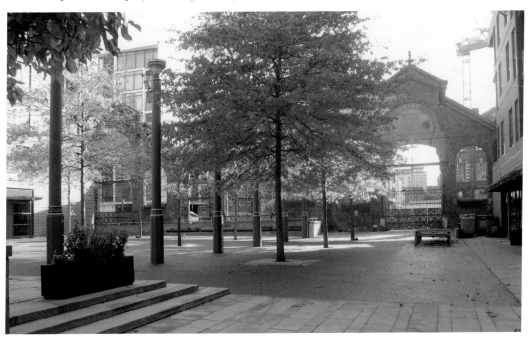

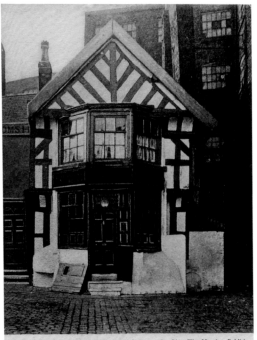

"The Rover's Return," Shude Hill, Manchester.

The Rover's Return, Shudehill, 1900
The Rover's Return claimed to be the oldest public house in the country, allegedly with a date on the building of 1306, whereas the Seven Stars Inn allegedly had a date of 1327. The Rover's Return was originally part of a building named Withingreave Hall, becoming a public house in the eighteenth century and demolished in 1958. Together with the Seven Stars Inn located close by, it formed a typical example of a Victorian backstreet scene in Manchester.

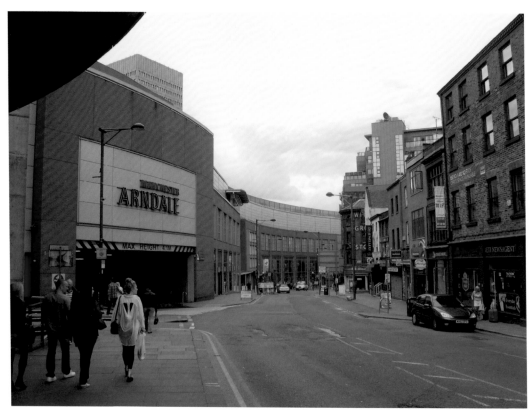

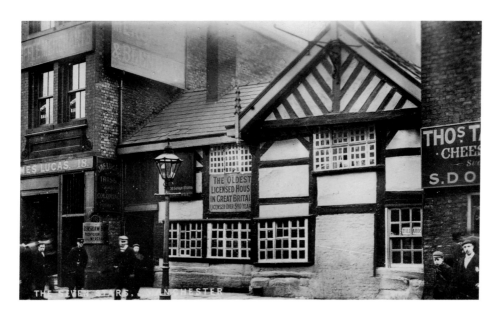

Seven Stars Inn, Withy Grove, 1907

The Seven Stars Inn was reputed to be the oldest licensed premises in Britain, founded in 1350, which was a fact much feted by Victorian Mancunians. A plaque to this effect was affixed to the front of the inn. Located near Shudehill, on Withy Grove, the Seven Stars was surrounded by warehouses and commercial premises, including the business of Thomas Tallis, shown next to the inn at No. 14. The buildings pictured here were demolished in 1911, with the area now beneath the Arndale Centre.

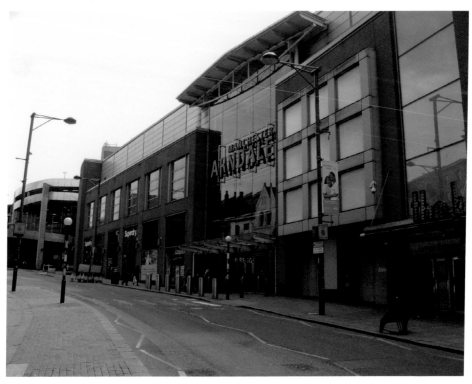

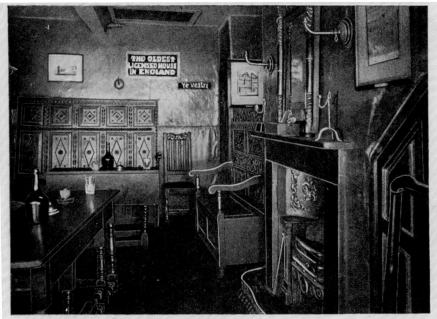

This room was formerly the meeting place of the Gentlemen constituting the "Watch and Ward." It contains the cupboard which has never been opened within the memory of anyone living. This is shown in the bottom right hand corner of the picture. In here are also to be seen the Old Man Trap, Leg Irons, and the folding doors of the Condemned Cell in the New Bailey Prison, which was sold to the L. & Y. Railway in 1872 and afterwards pulled down. The doors were presented by the Company to the Proprietor of the Seven Stars.

THE VESTRY. "Ye Olde Seven Stars," Manchester E. T. & Co., Copyright
(The oldest Licensed House in Great Britain)

'The Vestry' and 'Entrance to Secret Passage', Seven Stars Inn, Withy Grove, 1900
In the latter part of the nineteenth century, the Seven Stars continued to play an important part in Manchester's history. In 1885, during the course of structural alterations, silver plate was discovered. It is alleged that during the Civil War era, the inn was occupied by the troops of Charles I, who then hid their mess plate here, doubtless with the hope that it would be retrieved after the favourable conclusion of hostilities. The inn is also reputed to have been visited by Guy Fawkes.

In this cellar is an exceedingly old Arch (shown in the centre of the picture) which is the entrance to a passage which afforded communication with the old Collegiate Church and old Ordsall Hall. The Court Leet Records speak of one of the Clergy who, in 1571, was accustomed to go to the Seven Stars during sermon time, in his surplice, to refresh himself.

ENTRANCE TO SECRET PASSAGE. "Ye Olde Seven Stars," Manchester E. T. & Co.,
(The oldest Licensed House in Great Britain.) Copyright

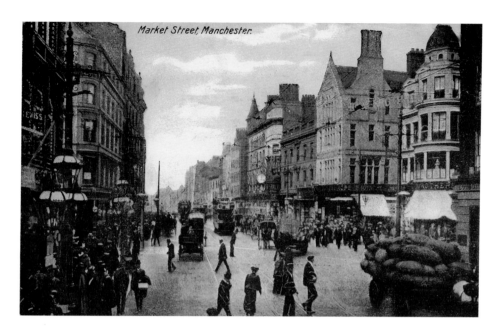

Market Street, Manchester.

Market Street, Looking Towards the Junction with Fountain Street (*Left*), 1906
Fountain Street's junction with Phoenix Street (*inset*) c. 1960, has been the site of an inn since
1771 and became the location of the Shakespeare public house in 1923. Other public houses
on Fountain Street included the Garrick's Head Inn adjacent to a theatre of 1803, which was
replaced by the Theatre Royal on Peter Street in 1844. The George and Dragon, the Swan
Hotel and an oatmeal market have also served Fountain Street's inhabitants. Like Spring
Gardens, Fountain Street is so named because natural springs were located here.

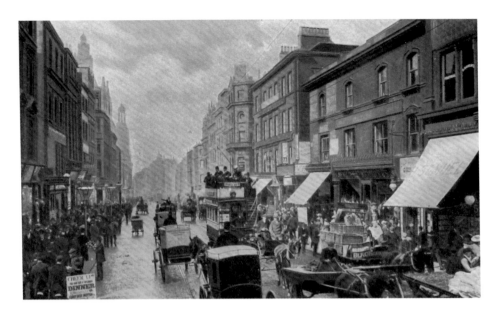

Market Street from Spring Gardens, Looking Towards St Mary's Gate and Deansgate, *c.* 1903
By the mid-1880s, thousands of people came in from the towns around Manchester, especially from the north, and spent their day window-shopping in an era when retail outlets were closed all day on Sundays. Occasionally, the streets were so congested that policemen had to part the crowds to allow horse trams access. Today, the Arndale Centre has replaced the retail and commercial buildings on the right, and Sunday trading is now an accepted feature of contemporary society.

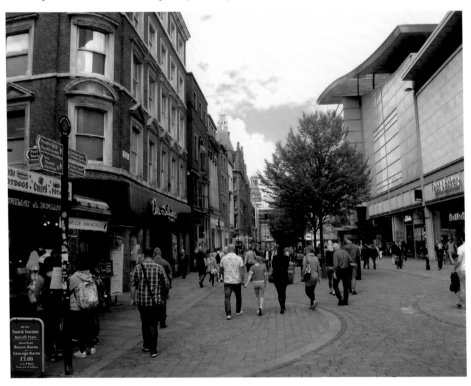

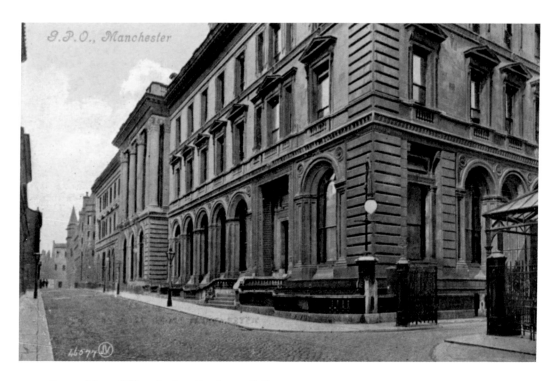

General Post Office, Spring Gardens, 1898

The General Post Office stood on Spring Gardens and was designed by the architect J. Williams. It was constructed between 1881 and 1887. A post office originally occupied part of the site on which the 1880s building was constructed and faced onto Brown Street. It was an imposing structure, built in Palazzo style, with a large central portico. The building closed as a post office in the 1960s and was demolished in 1968. It has since been replaced by the Zenith Building and a new post office, opened in 1969.

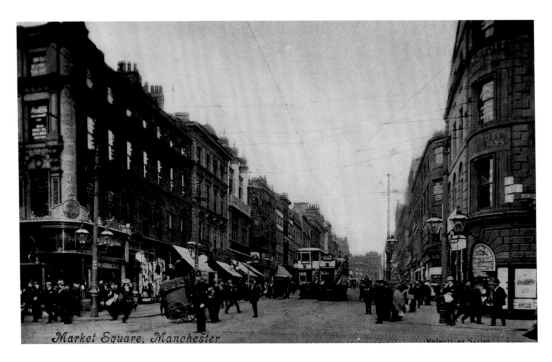

Market Street, Looking Towards Piccadilly, 1907
This photograph of Market Street is taken from its junction with Cross Street looking towards Piccadilly. It is today crossed by the Arndale Centre at this point. Behind the photographer is the Royal Exchange. Market Place is also behind the photographer, towards St Mary's Gate on the left-hand side and opposite St Ann's Square. It was home to a flower, fruit, vegetable and poultry market, with the nearby Old Shambles opposite the Wellington Inn, home to a fish market.

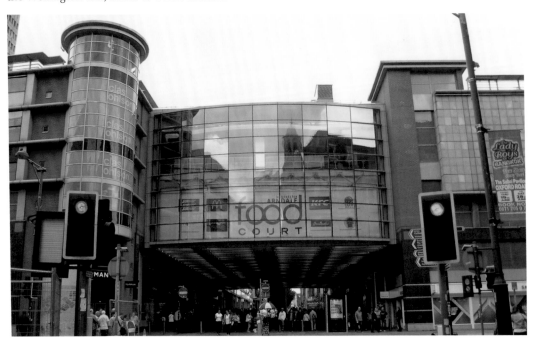

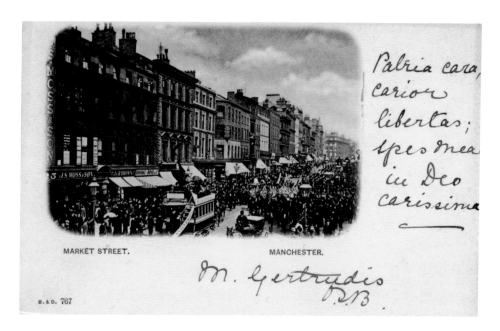

MARKET STREET. MANCHESTER.

Patria cara,
carior
libertas;
spes mea
in Deo
carissima

M. Gertrudis
D.B.

B. & D. 767

Market Street, from its Junction with Cross Street, 1889

Market Street was originally called Market Stede (Place) Lane. Before it was widened, the street was a narrow, crooked and steeply rising thoroughfare, so restricted in parts that only one cart could pass at a time. Eventually, an act of 1821 to improve Market Street was passed. The buildings shown in this photograph of 1889 (when trams were still horse-drawn) were constructed in 1850, with Market Street quickly becoming the main shopping district for Manchester from this time (*inset below, c. 1905*).

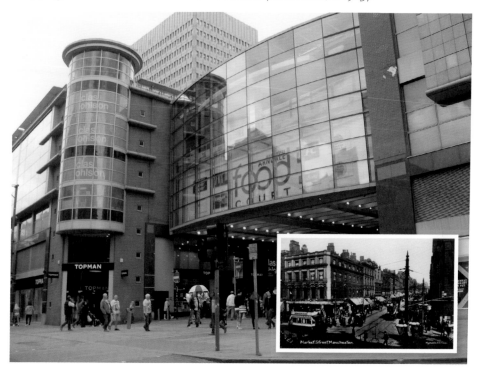

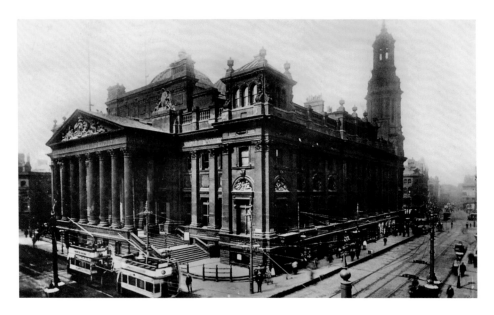

The Royal Exchange, Junction of Cross Street and Market Street, 1910
The first building was constructed by Sir Oswald Mosley in 1729, replaced in 1806–09 by Thomas Harrison and enlarged by Alex Mills in 1847–49. The present building was constructed by Mills & Murgatroyd in 1869–74, with an elaborate colonnade on Cross Street. It was modified by Bradshaw, Gass & Hope in 1914–21. It was built as a venue for trading, particularly cotton and textiles, and catered for 11,000 members (*inset*). Trading ended in 1968, and it is now home to the Exchange Theatre Co. and a retail arcade.

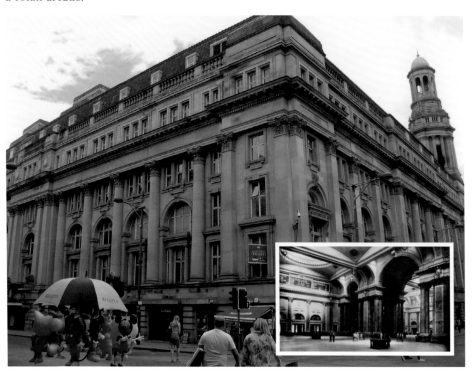

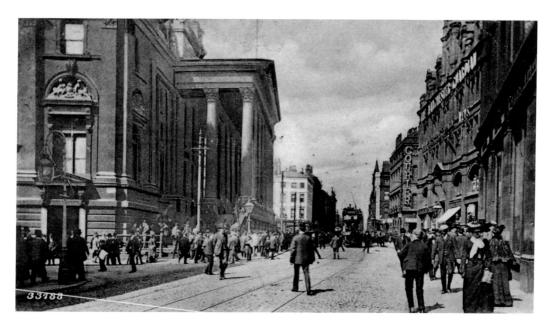

The Royal Exchange, Cross Street, Looking Towards Market Street, 1906
The present building is the third one to be built on this site. Construction started in 1869, with the first part opening on 2 October 1871 and completed in October 1874. The architect James Murgatroyd was invited back to oversee the demolition of the portico entrance and the extension of the building's façade to the pavement. This work was eventually completed in 1921. The 'Royal' prefix was gained after the royal visit of Queen Victoria and Prince Albert in 1851.

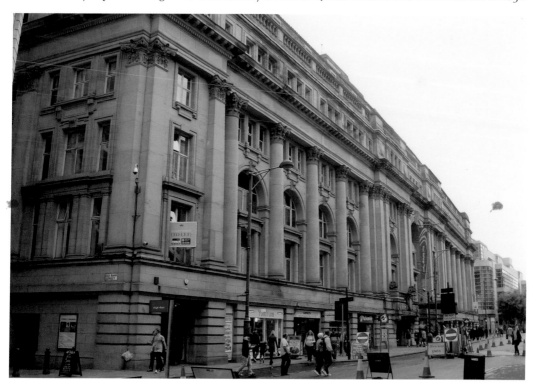

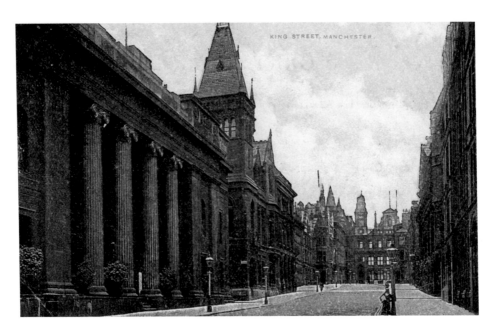

The Old Town Hall (*Left*), King Street, 1900

Built between 1819 and 1834 at the junction of King Street and Cross Street and opposite the former Branch Bank of England built in 1845/46 (*inset below*). The old town hall was designed by Francis Goodwin in Greek Revival style, with a colonnaded façade. As the Victorian city grew, its administration soon became too much for the building to cope with and in 1877 the new Gothic town hall, designed by Alfred Waterhouse, replaced it. The old town hall became a library and was eventually demolished in 1912.

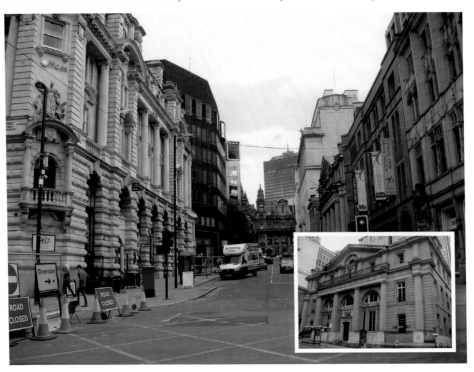

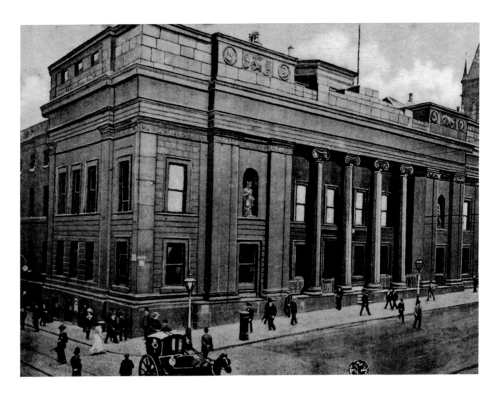

Reference Library, King Street, 1900, and Old Town Hall Portico, Heaton Park, 1912
In 1852, Manchester became the first authority to establish a rate-supported public lending and reference library under the Free Libraries Act. The Manchester Free Public Library opened at the Hall of Science, Campfield, near the Museum of Science and Industry. In 1877, the first building became unsafe. The library moved to the old town hall, which then became too small. It was resituated to a temporary location at Piccadilly in 1912. The façade of the old town hall was reassembled in Heaton Park.

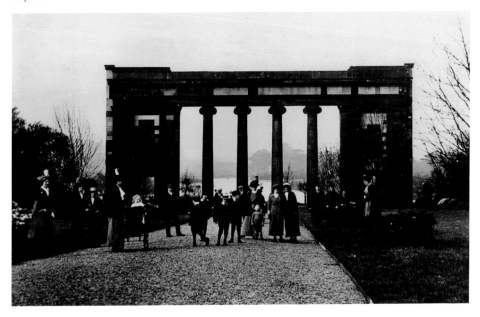

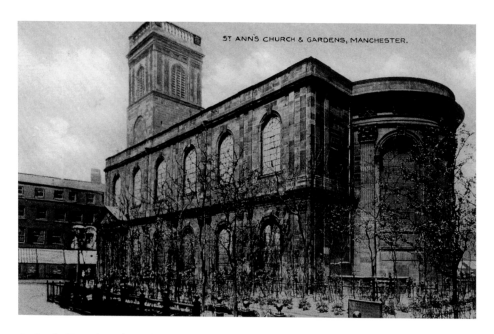

St Ann's Church and Gardens, St Ann's Square, 1900

A foundation stone was laid in 1709 by Lady Ann Bland of Hulme Hall – the Lady of the Manor. The building was originally constructed with a three-stage cupola, which was removed in 1777 and replaced by a spire. This in turn deteriorated and was replaced by a tower, which itself was removed and replaced. Sir Alfred Waterhouse was responsible for the extensive and well executed restoration work, including the Nave's Choir, which took place between 1887 and 1891 (*inset*).

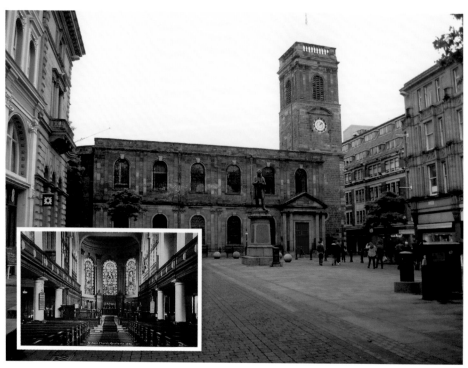

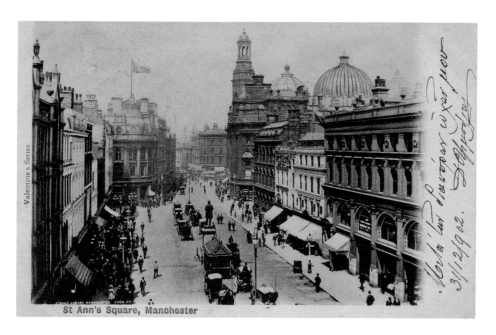

St Ann's Square, Manchester

St Ann's Square and the Royal Exchange, 1902

St Ann's church and square was originally a cornfield named Acres Field, which was the venue for Manchester's September fair. As residential properties were built in the area, the fields diminished. These eventually gave way to shops and offices built in the mid-to-late Victorian era. Small 'courts' (around the 1600s) of mixed use properties situated around Market Street were demolished to make way for these developments, including Hallsworth's Court, Old Millgate, where the company of my ancestors, Hallsworth & Dewhurst, Fustian Calenderers, was located.

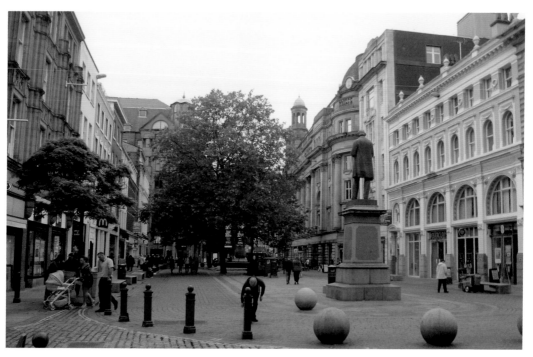

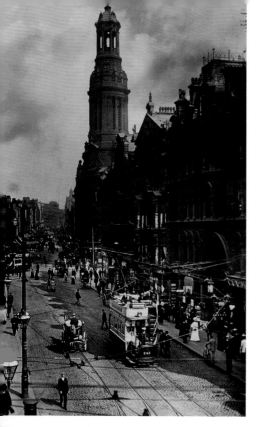

St Mary's Gate, Market Street and the Royal Exchange, *c.* 1905
The buildings on the right, from St Mary's Gate, have now been replaced by modern constructions, although the tower of the Royal Exchange building remains a landmark at this end of Market Street. The area on the left, towards the junction with Corporation Street, was reconstructed after the 1996 terrorist bombing. On 3 September 1895, the Northern Rugby Football Union, which became the Rugby Football League, held its first full meeting at the Spread Eagle Hotel, once located near to Selfridge's store.

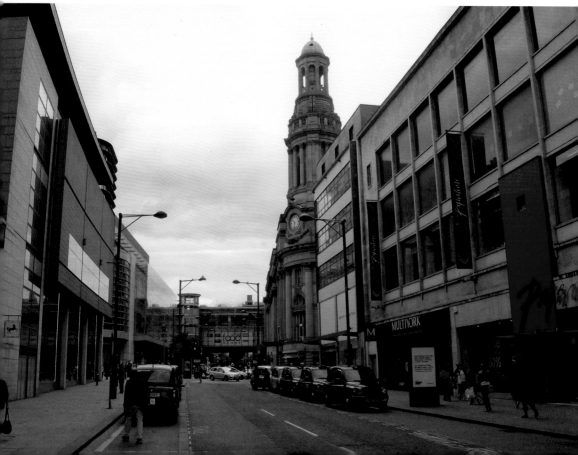

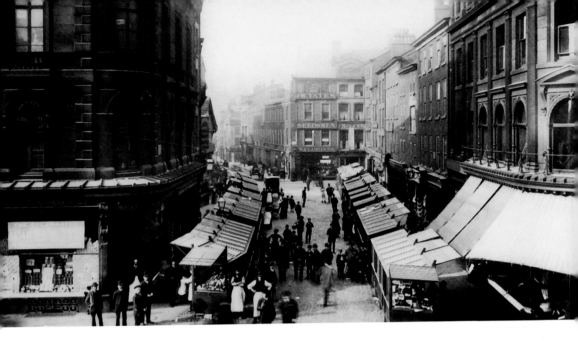

Victoria Market, Market Place, Before Reconfiguration, 1885

Market stalls are shown on both sides of the marketplace, with the roof of the Old Wellington Inn just visible on the left. Victoria Market was the location of a flower, fruit, vegetable and poultry market, with a fish market beyond the inn. The area has gone through a number of changes. The inn (and Sinclair's) has been moved twice, standing nearby in Exchange Square. The site of the former Market Place is now the location of Marks & Spencer on Market street – on the right of the modern image (*inset*).

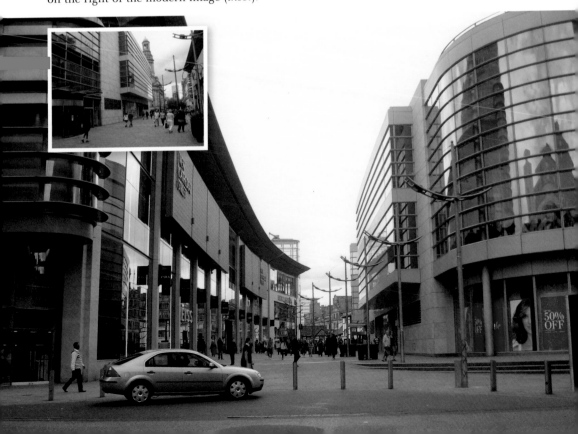

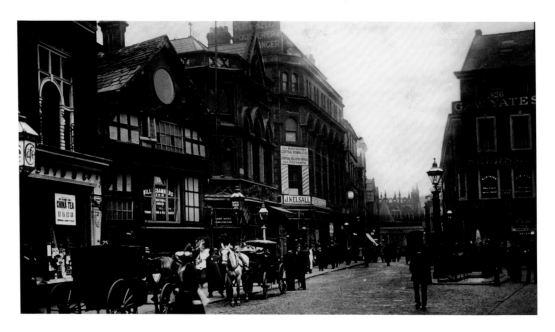

Market Place, Looking Towards the Royal Exchange and St Mary's Gate Before its Reconfiguration, 1900

The commercial centre of the city, this area was bombed during the Second World War. However, the Old Wellington Inn and the adjoining Sinclair's Oyster Bar, both from around the 1300s, survived. The present Sinclair's replaced the first John Shaw Punch House of 1738, later becoming the venue for Manchester's first 'gentleman's' club. The modern image shows Selfridge's store, with the Corn Exchange, Shambles, cathedral and the Mitre reflected in its glass frontage. Together with Marks & Spencer, it covers the site of the old Market Place.

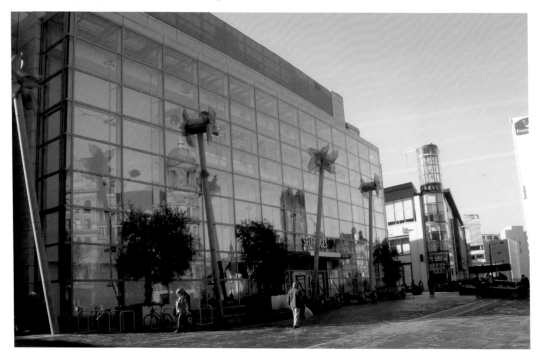

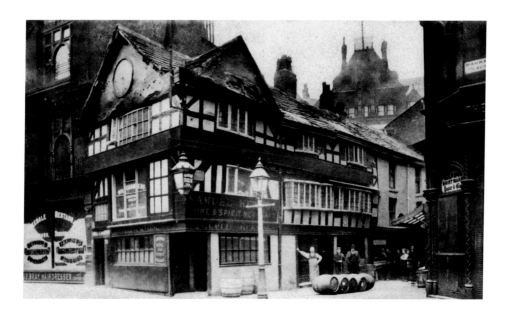

The Old Wellington Inn, Market Place, 1903

Said to date from around 1300, the present inn was constructed around 1550, although repeated rebuilding has drastically altered its appearance. It was a private house until it became an inn from 1830 and is famous as the birthplace of author John Byrom. The Old Wellington Inn is the only surviving example of an original timber-framed building in the city centre (*inset*), and has been raised twice from its original position, being relocated to Shambles Square in 1971 and then Cathedral Gates, Exchange Square, in 1998/99 after the 1996 terrorist bombing.

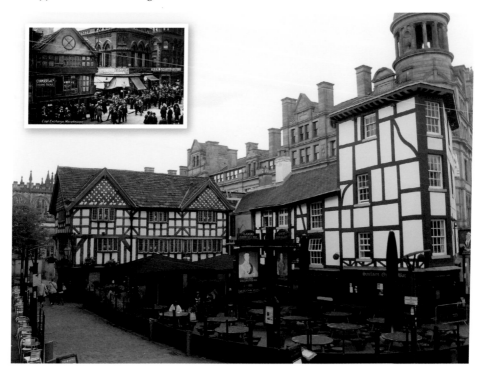

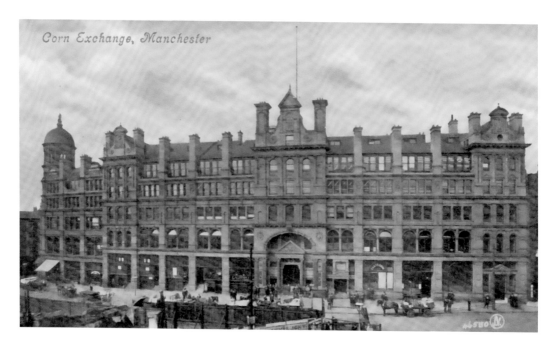

Corn Exchange, Manchester

The Corn Exchange, Hanging Ditch, 1903

The first corn exchange was built here in 1837 and was designed by Richard Lane, who was regarded as one of Manchester's leading architects. Lane's building was demolished and replaced by the present one in 1897. It was constructed in two sections by different architects in 1897 and 1903, and has a glass dome, which was originally built to provide a source of natural light for the trading floor. The building was severely damaged by terrorist bombing. Its reconstruction created a new indoor retail centre and Exchange Square.

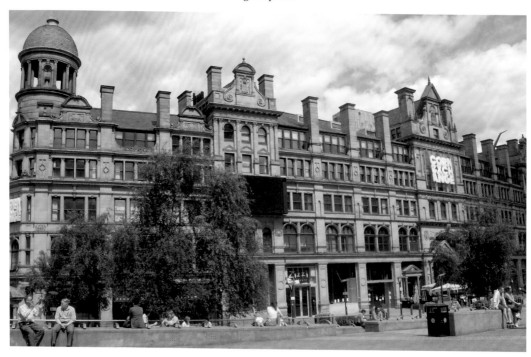

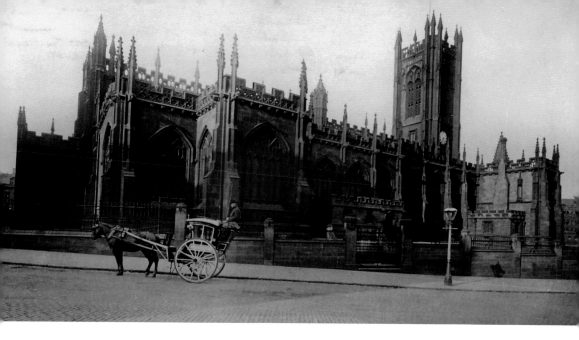

Manchester Cathedral, 1900, and the Mitre, Once Home of the Manchester Literary Club, 1862
Manchester Cathedral underwent extensive renovation in 1860–68, with the tower rebuilt in 1864–68 to the same design as the previous one. An extra 6 feet was added on top of the original height of 124 feet. The nineteenth century also saw the reconstruction of the Nave interior in 1882/83, with the present entrances built in 1889, 1891 and 1897. A new baptistery extension was added in 1892. Victorian artist, Dickens biographer and local historian Robert Langton commented on some of this work in the *Transactions of the Lancashire & Cheshire Antiquarian Society*, 1886.

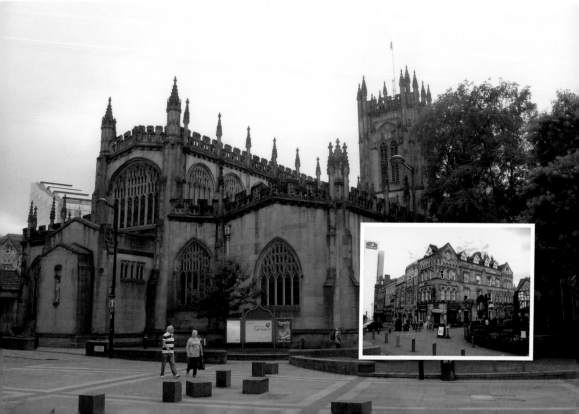

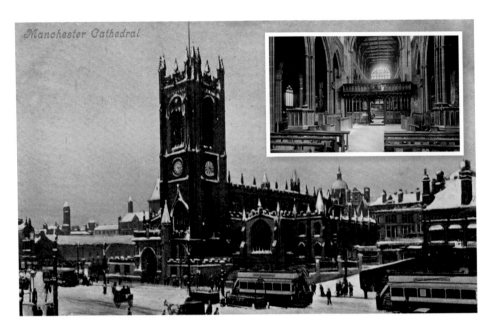

Manchester Cathedral in the Snow, 1903 and the Screen, 1900

Dating from the fifteenth and sixteenth centuries, the parish church of Manchester only became a cathedral in 1847. Robert Langton (1886) wrote, '… Manchester Old Church has been so patched and plastered, veneered outside, and almost rebuilt within, that very little of its ancient character remains. I am bound, however, to say … that though some of the work now in hand cannot in any sense be said to be a true restoration, yet the work is being done with extreme care and skill…'

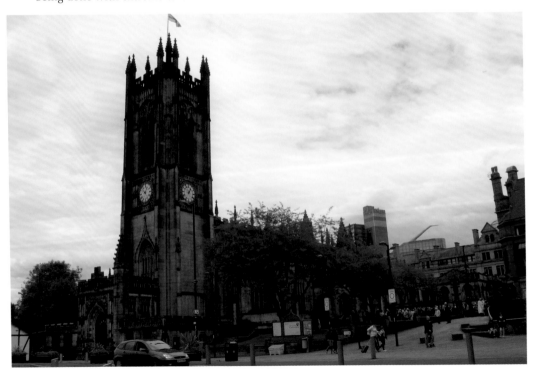

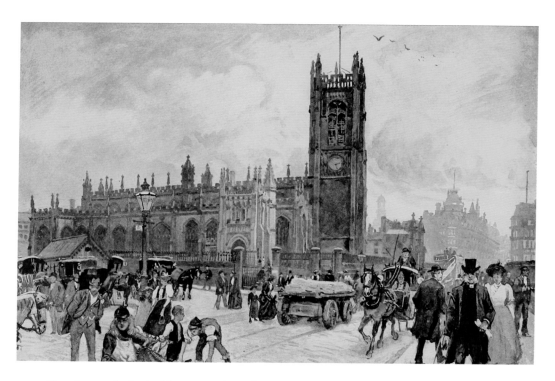

Manchester Cathedral from Hunt's Bank, 1894

This illustration and the later inset photograph of 1961 show graphically the restricted site occupied by the cathedral. This restriction was something that had not gone unnoticed by Robert Langton who wrote an article called 'Cathedral Restorations' for the *Manchester Guardian* as early as 1874 in which he favoured demolition of the 'old church' and the construction of a new cathedral in a more spacious area of the city. However, this ancient site, with its centuries of parish church history, remains the cathedral's location.

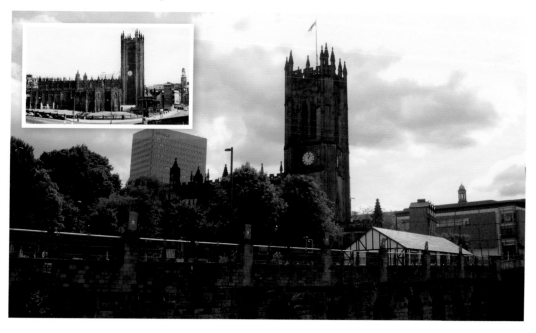

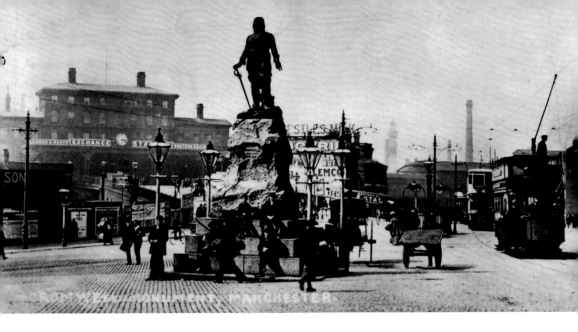

Cromwell Monument and Exchange Station, 1907
In the early 1840s, the station site was occupied by the Red Lion Inn and a woollen cloth hall. The LNWR's route to Leeds commenced service in 1849 and Exchange station was opened 1884, to cater for increased demand. The station (*inset, interior*), derived its name from the nearby Cotton Exchange, with the building in Salford and bridge, named Cathedral Approach, shown over the River Irwell in 1907. Cromwell's Monument, controversially erected in 1875 by local Liberal politicians, is now located at Wythenshawe Park.

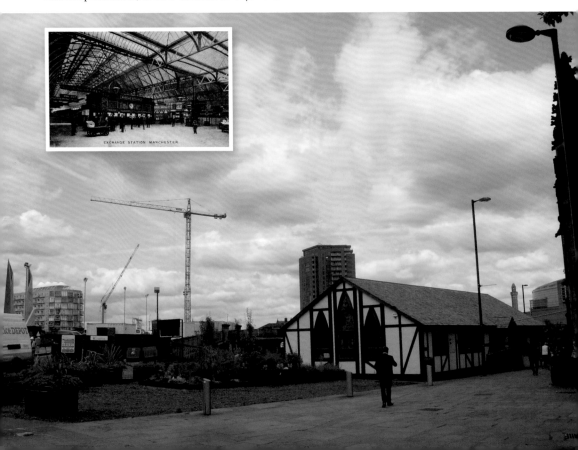

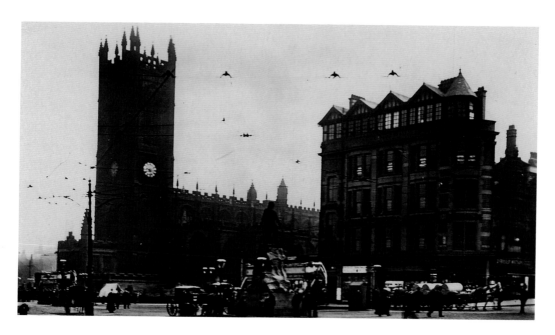

The Cathedral and Cromwell Monument, Junction of Deansgate and Victoria Street, 1894 & c. 1905

Manchester was regarded as a 'Roundhead' stronghold during the English Civil War. There have been recent plans (2011) to reinstate the monument in Manchester's Medieval Quarter, which would be built around a new Cathedral Square. The monument was by Matthew Noble (1861) and was a gift to the city from Mrs Abel Heywood. It was disliked by the city's large Irish immigrant community. When Queen Victoria declined an invitation to open Manchester's new town hall, she allegedly requested the monument be removed.

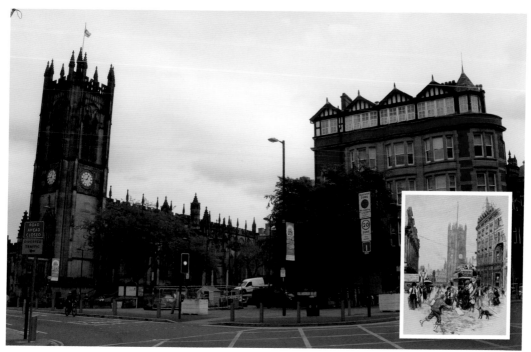

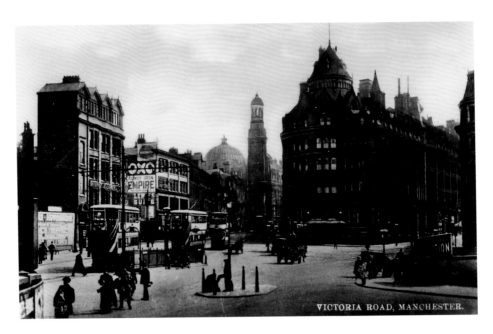

VICTORIA ROAD, MANCHESTER.

Hanging Bridge Chambers, Victoria Street, Victoria Buildings, Deansgate and Cromwell Monument, 1907

The Cromwell Monument can just be seen in the shadow of Victoria Buildings at the junction of Deansgate and Victoria Street where it stood until it was removed for a traffic scheme. The monument, which is Grade II listed, was then put into storage and eventually installed at Wythenshawe Park. The tower of the Royal Exchange can also be clearly seen, and to its left is a narrow building called Hanging Bridge Chambers (1880/81), sited over the medieval Hanging Bridge – now the Cathedral Visitor Centre.

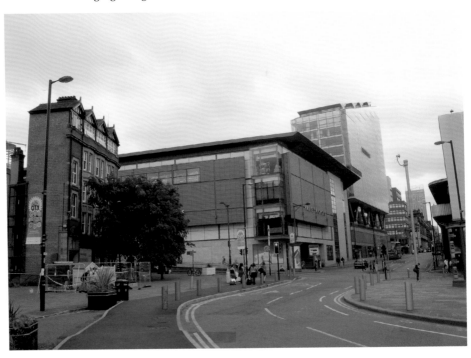

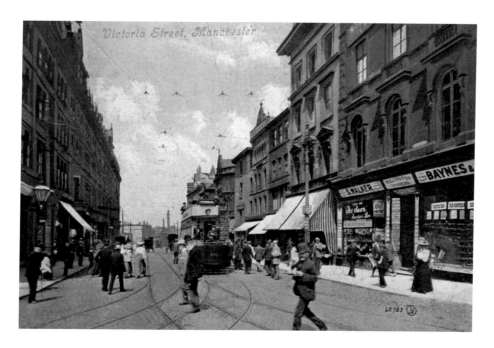

Victoria Street, Deansgate, Before Reconfiguration, 1908 and New Cathedral Street, 2014
On the left is Victoria Buildings, once home to the Victoria Hotel. The building had shops at street level and contained offices throughout. In December 1940, the building was hit by incendiary bombs, with only its shell surviving. It was later replaced by Victoria Gardens. The site is now occupied by the retail building containing Harvey Nicholls and Marks & Spencer, with Zara on the left the approximate location of the lamp post on the right of the image from 1908.

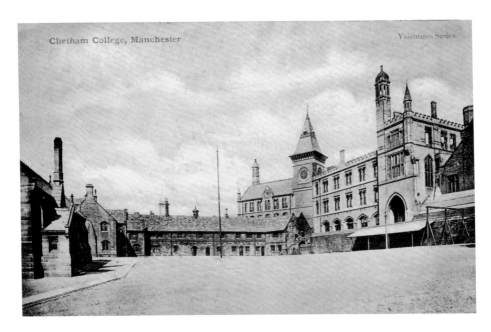

Chetham's College, 1904, Dormitory Steps, 1900, and from Long Millgate, 2014
Humphrey Chetham left instructions in his will of 1653 to purchase the collegiate buildings in order to found a school for forty impoverished boys who were to be educated and clothed from the ages of six to fourteen, and then placed in apprenticeships. He also established a free library. In the Victorian era, it was the meeting place of Karl Marx and Friederich Engels, and provided choristers for the cathedral – later becoming a grammar school and then a music school.

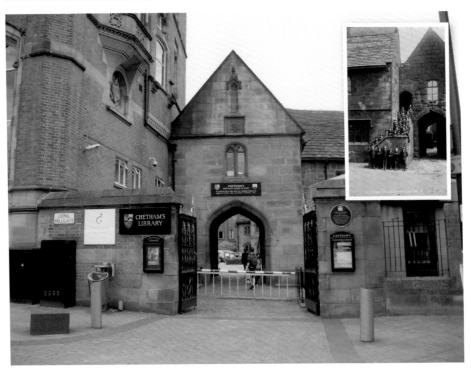

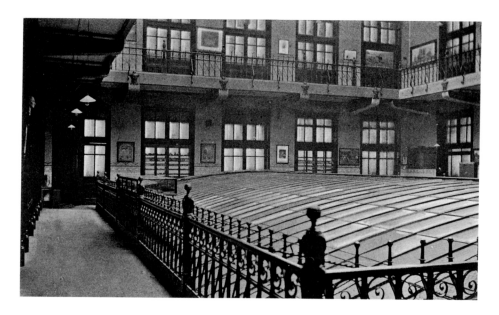

Manchester Grammar School, Long Millgate (1776–1931) and a Corridor with Classrooms (*above*), 1900

Founded in 1515, the original school was replaced by one on Long Millgate street in 1776. The increased number of fee-paying students in the 1860s led to the construction of a building in 1869–70 on the side of Chetham's College gatehouse – later a teacher training college (*below*). In 1871, a new building was designed by Alfred Waterhouse and built in 1876/77 when the 1776 building was demolished. Modern buildings were joined to the original school by a glass-sided stone bridge (*inset, 1894*).

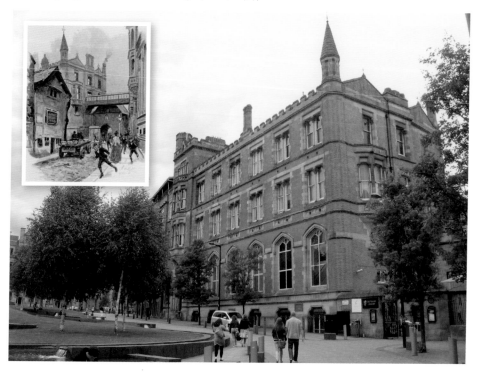

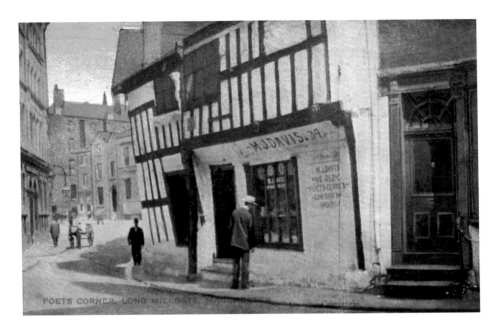

Poet's Corner, Long Millgate, 1900

Now Cathedral Street and Urbis (2000/01), once wholesale businesses with cellar warehouses (*inset, 1921*), proliferated here. Long Millgate is shown where it curves towards Todd Street with Chetham's College gatehouse behind the photographer. The gentleman pictured is looking into the window of 'Ye Olde Poet's Corner Curiosity Shoppe', originally the Sun Inn, *c.* 1647. It became a meeting place for Manchester poets in the nineteenth century. They founded the Lancashire Authors Association and published an anthology called *The Festive Wreath* in 1842, edited by John Bolton Rogerson.

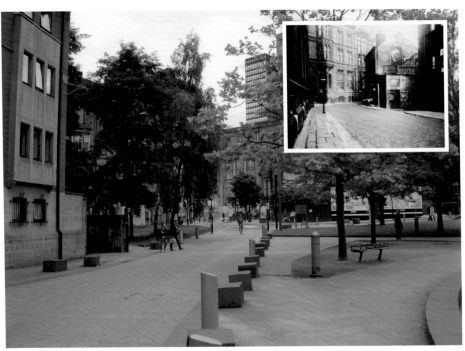

Victoria Station, Victoria Station Approach, 1911

Victoria station, designed by Robert Stephenson, opened on Hunt's Bank in 1844 operating trains to the north, west and east of Manchester. Local architect William Dawes later designed Victoria's main building in 1909 housing the offices of the Lancashire & Yorkshire Railway. The company's major routes were displayed on a large mural located just inside the station's main entrance hall (*inset*). Exchange station, built next to Victoria, initially operated trains to Leeds, with the combined Exchange–Victoria platform the largest in Britain (2,194 feet).

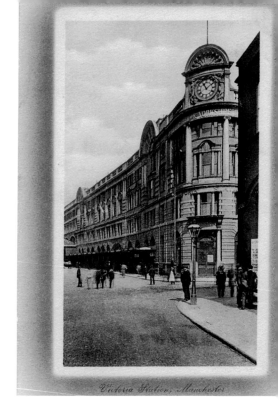

Victoria Station, Manchester

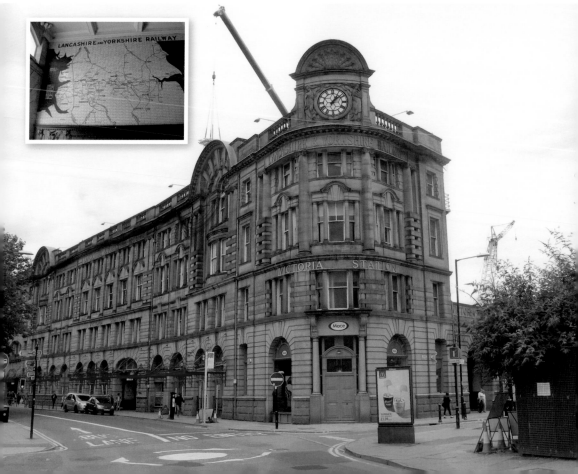

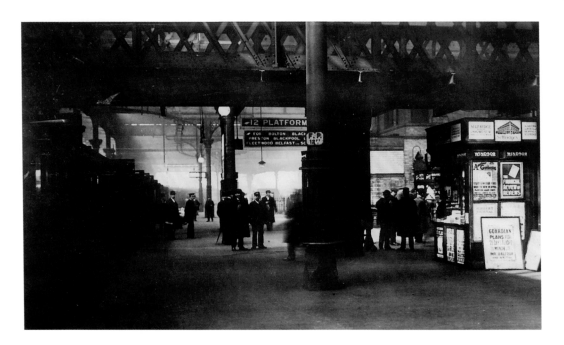

Platform 12, 1902, and Junction of Hunt's Bank & Victoria Station Approach, 2014
Robert Stephenson's original station was a long, single-storey building located next to a single platform. A section of that original station (the central block) can still be seen on Hunt's Bank to the left on the modern photograph. It was once the station's refreshment room, with its single storey extended in later developments. Destinations from Platform 12 included Fleetwood, Belfast, Douglas (Isle of Man) and Scarborough. The area around Walker's Croft, close to the station site, was once a cemetery.

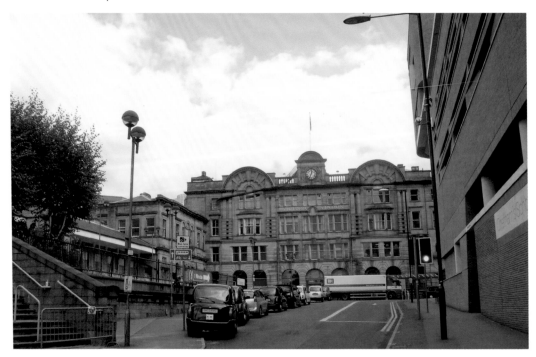

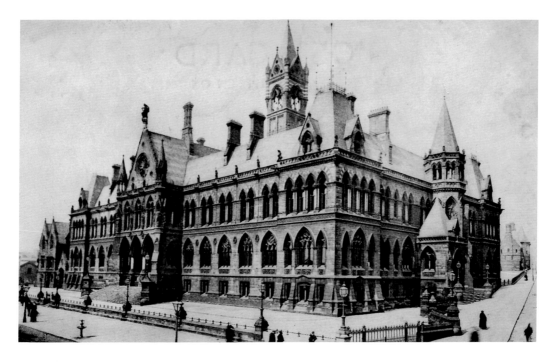

The Assize Courts, Great Ducie Street, 1903
The courts were constructed in Venetian Gothic style on the site of the former Strangeways Hall and Park. The architect was twenty-nine-year-old Alfred Waterhouse, winner of a design competition with 107 submissions. Building began in 1859, with the first hearings taking place in July 1864. The courts overlooked Great Ducie Street, with Strangeways Prison behind them. They were destroyed in the Blitz of 1940/41. The surviving façade, facing onto Great Ducie Street, was eventually demolished in 1957.

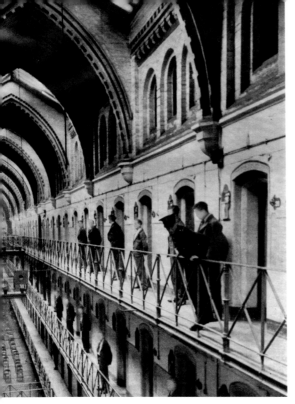

Strangeways Prison's Gothic Arches
c. 1940, and Gatehouse, Junction of
Carnarvon & Southall Street
The neighbouring Assize Courts building
was the tallest in Manchester until
1877. Today, the 244-foot chimney of
Strangeways Prison dominates this
district of North Manchester. Even before
the courts were finished, Waterhouse was
commissioned to design the adjoining
Grade II listed prison, built 1866–68.
Constructed on the site of Strangeways
Hall and Park, adopting the name,
the prison opened on 25 June 1868. The
building had a 'radial' design, with wings
attached to a dodecagonal central hall,
accommodating 1,000 prisoners and
two gatehouses.

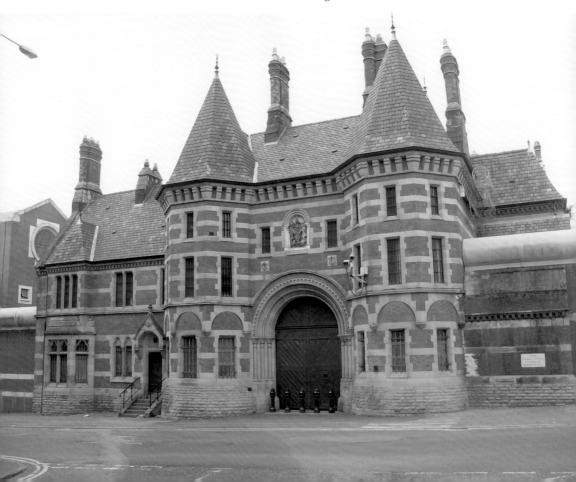

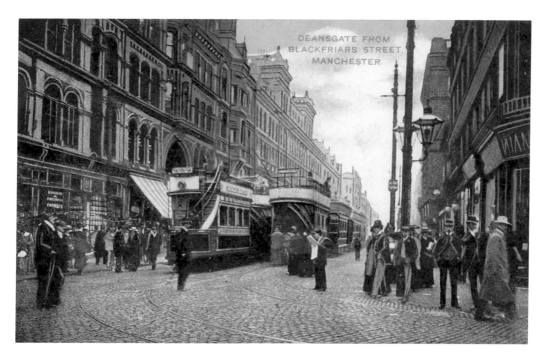

Deansgate from Blackfriars Street, *c.* 1905

The trams shown are heading the same way on shared tramlines to make turning around easier. Tramlines were laid around Victoria Buildings so that they could circle it and face outward again. Barton's Buildings (*centre*), designed by Corbett, Raby & Sawyer in 1871, is a façade for the Barton Arcade – a glass and iron shopping arcade with two octagonal glass domes 53 feet high. It is the only survivor of three such arcades in Manchester and probably the best example in the country.

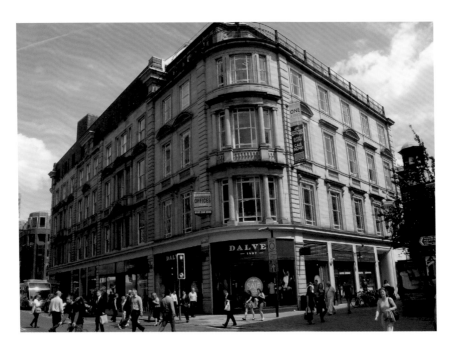

Former Kendal Milne Department Stores, Deansgate and Junctions with King Street and St Mary's Street

The original Kendal Milne Department Store (*above*) was designed by E. J. Thompson (1872/73) and ran to the junction with King Street, opposite the twentieth-century store, where a curved corner was incorporated into the design. The modern Kendal Milne Department Store, now House of Fraser, was designed by J. S. Beaumont in 1939, and was connected to the original store by a tunnel beneath Deansgate. St Mary's Street, alongside the modern store, was named after St Mary's church (1753–1890) located at Parsonage Gardens.

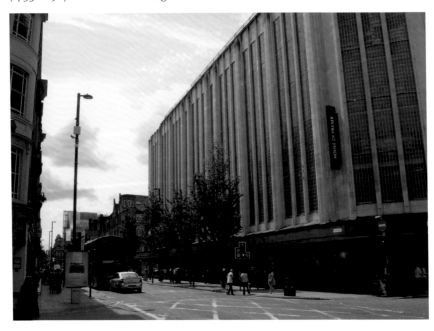

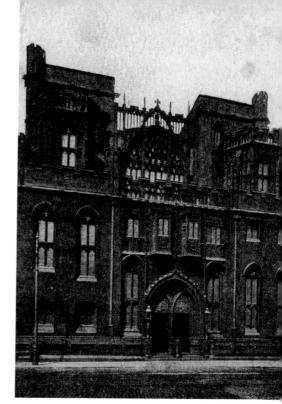

The John Rylands Library, Deansgate, 1900
Opened formerly in January 1900, it is a
tribute by his wife, Enriqueta Augustina, to
John Rylands of Longford Hall, Stretford – a
Nonconformist philanthropist who made his
fortune from textiles. Her association with
the library continued after its construction
(1890–99) as she endowed it with a yearly
income for maintenance and extension.
Designed by Basil Champneys, the library
merged with the University of Manchester
library in 1972. It was one of the first
buildings in Manchester to use electric
lighting (*inset, interior*).

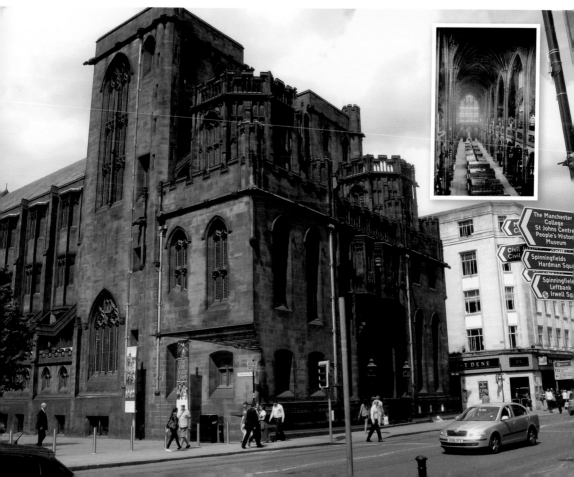

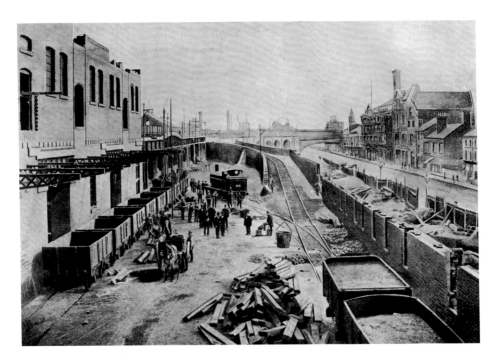

Former Great Northern Railway Offices & Goods Station, Deansgate, Looking Towards Castlefield, 1898

Opposite Royal London House (*inset*), at Deansgate's junction with Quay Street and Peter Street, stood the Great Northern Railway offices warehouse – now a retail and leisure complex – and goods station, shown under construction in 1898. The offices form a façade to what was once the railway's goods station and consist of a long and uniform selection of business outlets along the whole east side. They are only one room deep, creating a screen wall to the former warehouse complex behind them.

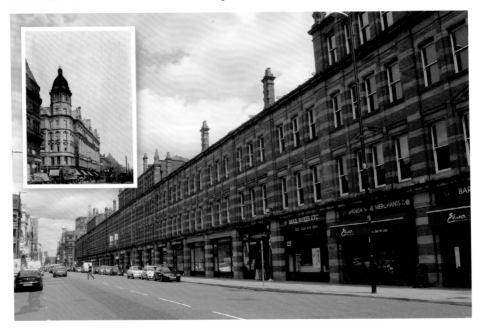

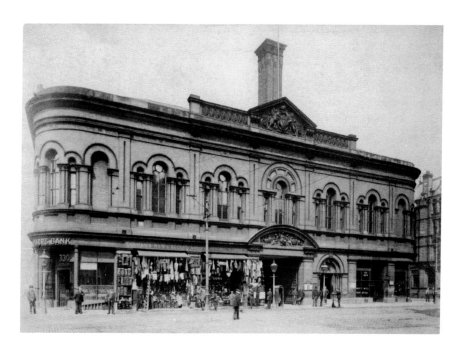

Deansgate Free Reference Library, 1900

The former Deansgate Free Reference Library is located between Liverpool Road and Tonman Street. The building is situated in front of Higher Campfield Market (1878) and is linked to it by a glazed arcade (*inset*). The second Free Reference Library on this site, it was designed by George Meek and opened 1882. It was later used as the Castlefield Visitor's Centre, but is now home to several retail premises. Despite its history of multi-use, it is still recognisable from the photograph of 1900.

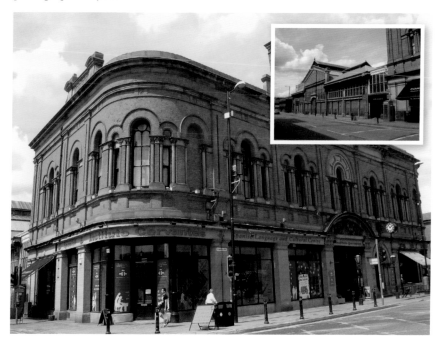

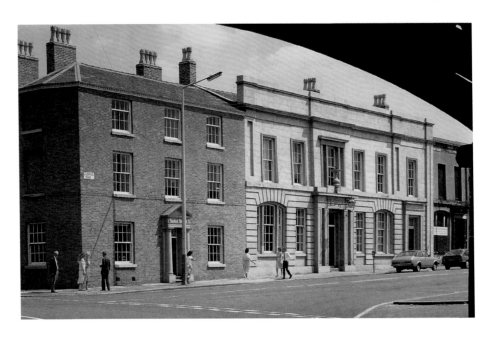

Liverpool Road Railway Station, Looking Towards Deansgate, *c.* 1985, and Water Street, 2014

The world's oldest passenger railway station built in 1830 with the brick-built station agent's house, constructed in 1808 as private accommodation, on the left. In the Victorian era, Liverpool Road became part of the LNWR and was used as a passenger station until 1844 when Victoria station opened. It carried on as a goods depot for the remainder of the nineteenth century and closed in 1975. It was then used to house the Museum of Science and Industry, opened in 1983 (*inset*).

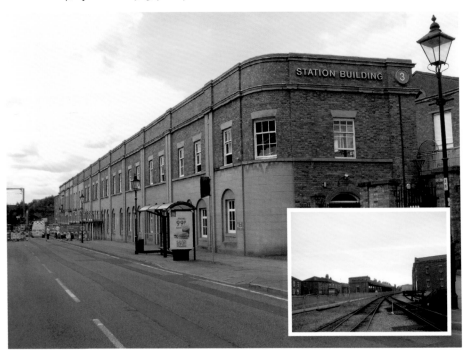

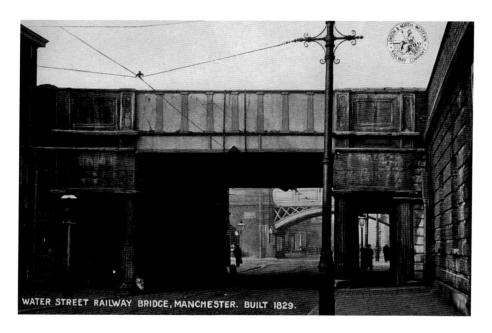

WATER STREET RAILWAY BRIDGE, MANCHESTER. BUILT 1829.

Water Street, Old Railway Bridge, 1894 and as seen from Liverpool Road Station, 2014
George Stephenson's Liverpool & Manchester Railway was the first intercity passenger
service with a regular timetable powered by steam. When the railway arrived in
Manchester, its terminus was initially on the Salford side of the River Irwell. Eventually,
land was earmarked at Castlefield for a station, with Water Street crossed by a bridge
(*inset*) designed by William Fairbairn and Eaton Hodgkinson. It was cast at their factory in
Ancoats and was constructed in 1829–30. Spanning Water Street throughout the Victorian
era, the bridge was replaced in 1904.

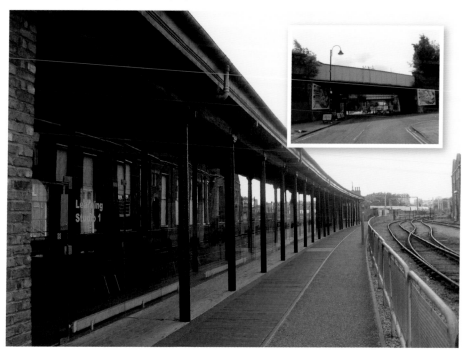

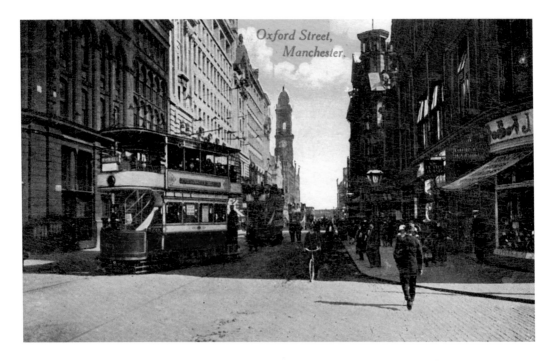

Former Refuge Assurance Co. Building, Junction of Oxford Street and Whitworth Street, 1907
Now a hotel, it consists of two buildings. The first was designed by Alfred Waterhouse in
1891–95, and the second by his son, Paul, in 1910–12, with an extension along Whitworth
Street by Stanley Birkett in 1932. It is dominated by a 217-foot-tall clock tower. A second tower,
complete with spire, near the junction of Oxford Street and Whitworth Street, no longer exists.
Portland Building, now Oxford Place, at the Portland Street junction, was designed around 1860
by Philip Nunn for Louis Behrens & Sons.

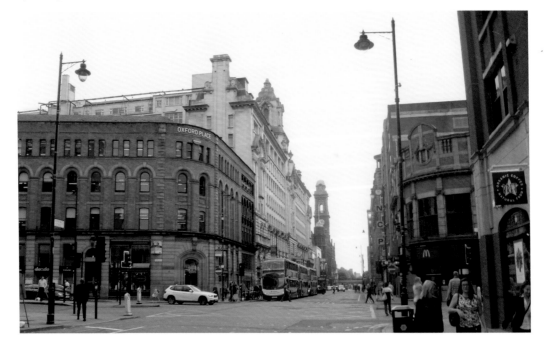

84

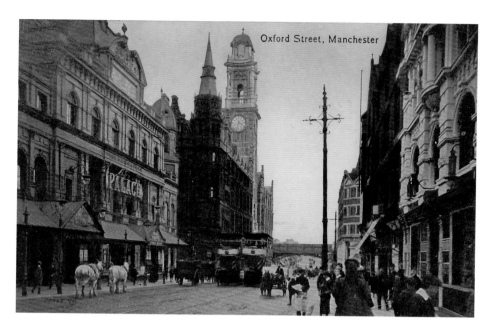

Oxford Street, Manchester

Oxford Street, Palace Theatre and Former Refuge Assurance Co. Building, 1907
This view of Oxford Street is taken from in front of the former offices of textile manufacturers Tootal, Broadhurst, Lee & Co. (*inset*), designed and constructed by J. Gibbons Sankey in 1896–98. The red-brick building is striped with orange terracotta and has distinctive polygonal corner towers. The interior featured a war memorial by Henry Sellers. The offices are opposite St James' Buildings. The photograph here shows the Palace Theatre and Refuge Assurance Co. Building, now a hotel, looking towards Manchester University.

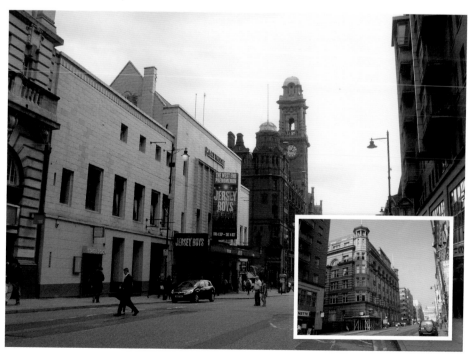

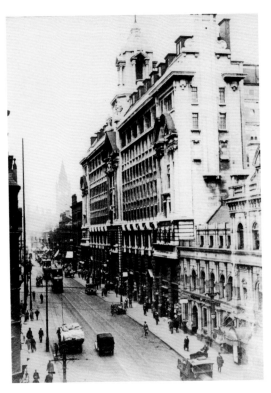

St James' Buildings (*Centre*), Oxford
Street, *c.* 1920
St James' Buildings were formerly the
headquarters of the Calico Printers
Association, which was founded in
1899 by the amalgamation of forty-six
printing companies and thirteen
merchant enterprises. Some of these
members were occupied with weaving
and spinning interests. The total number
of members was 128. They also had
important overseas interests, particularly
in spinning, weaving, merchandising
and finishing. The Calico Printers
Association's affluence is reflected in the
grand appearance of their warehouse
façade (1912/13) overlooking Oxford
Street.

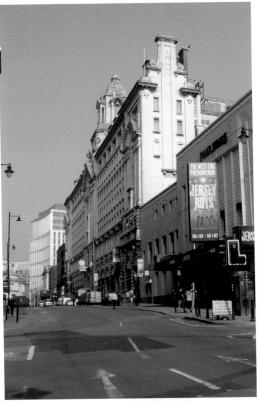

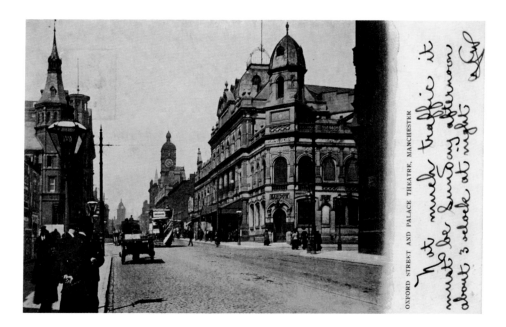

The Palace Theatre, Oxford Street, 1902

The theatre's first performance took place on Monday 18 May 1891 in a building that cost £40,500. The ballet *Cleopatra* from the London Empire was the first performance, with seats priced from 6*d* to 4*s*. Designed by Alfred Derbyshire, it had seating for 3,675 people. The Palace has altered in looks considerably since 1891. It was renovated externally in 1956 when the beige-tile cladding, shown in the modern image, was added. It was renovated internally with improved circulation and new backstage facilities in 1981.

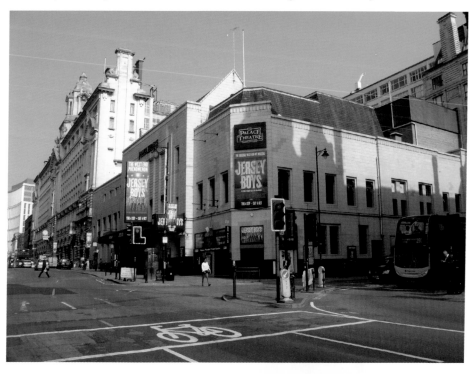

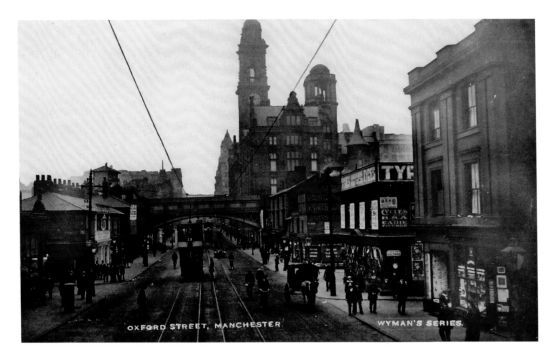

OXFORD STREET, MANCHESTER WYMAN'S SERIES.

Former Refuge Assurance Co. Building, Oxford Street, c. 1910, and Oxford Road Railway Station, 2014

This photograph of Oxford Street looking towards St Peter's Square is a rare view taken from the upper deck of a tram. The retail outlets, including the cycle shop on the right, have now been replaced by an office block at Oxford Street's junction with Charles Street. However, the railway bridge across Oxford Street remains a landmark here, as does the tower of the Refuge Assurance Co. building, now the Palace hotel. Oxford Street remains a major route into the city centre.

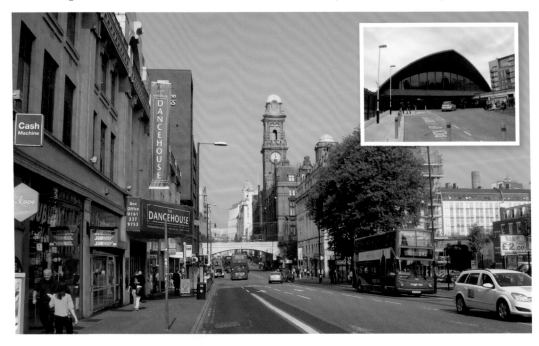

Paulden's Department Store, Cavendish Street, 1896, and Manchester School of Art, 2014

William Paulden began trading on Cavendish Street, close to Stretford Road, in the 1860s, continuing in the area until 1957. The store, shown 1896, was built in 1879 and rebuilt in 1930. It was destroyed by fire in 1957. In 1959, Paulden's store reopened on Market Street in the former Ryland's warehouse, which was constructed in 1932 and is now a Debenham's store (*inset*). Today, the site is occupied by the Manchester Metropolitan University (*ahead*) close to Manchester School of Art (*left*), founded in 1838 and where artist Adolphe Valette once taught.

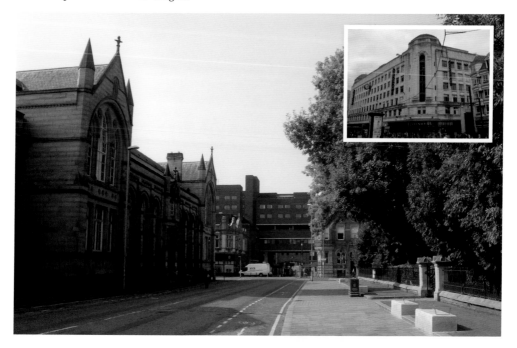

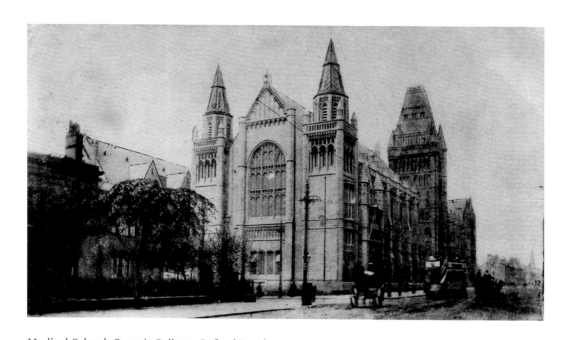

Medical School, Owen's College, Oxford Road, 1904

Owen's College opened in 1851, incorporated the Medical School in 1872 and moved to its present site in 1873 when post-elementary education was increasing in popularity. It became the first college of the Victoria University in 1880, acquiring its independence in 1904 as the Victoria University of Manchester. Land for the college was purchased in 1870, with the main block of buildings and tower designed by Alfred Waterhouse in 1869–74. Whitworth Hall, in the centre of the photograph, was added by Paul Waterhouse in 1895–1902.

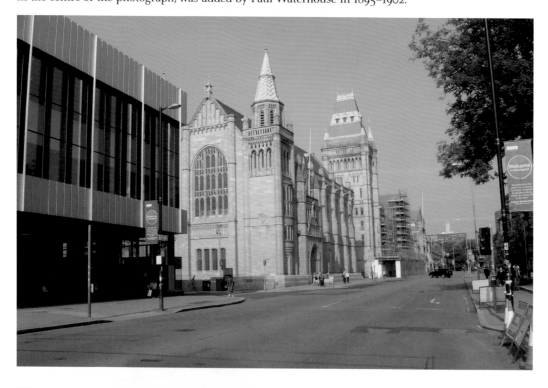

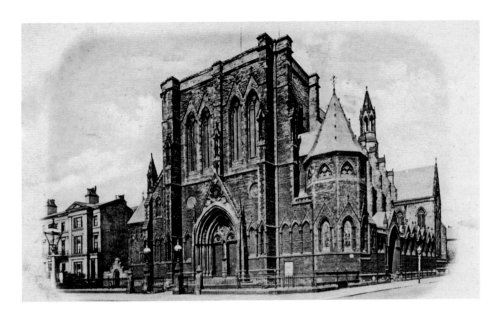

Church of the Holy Name of Jesus, Oxford Road, 1900

The foundation stone was laid in 1869 and the church opened on 15 October 1871. The architect was Joseph Aloysius Hansom, who designed his church in the fourteenth-century French Gothic style. The church tower, as originally designed by Hansom, would have been higher than the present tower, but was not built due to unstable ground conditions. In 1928, the present church tower (*inset*) was completed as a memorial to Fr Bernard Vaughan S. J. – Rector of the Holy Name from 1888–1901. It is 185 feet high.

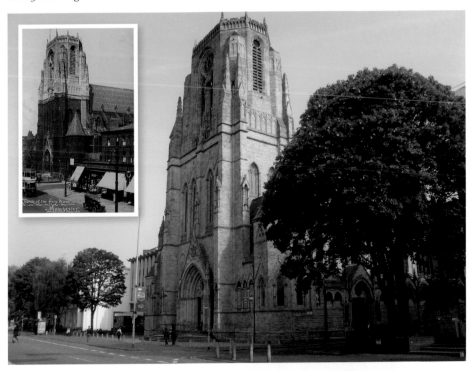

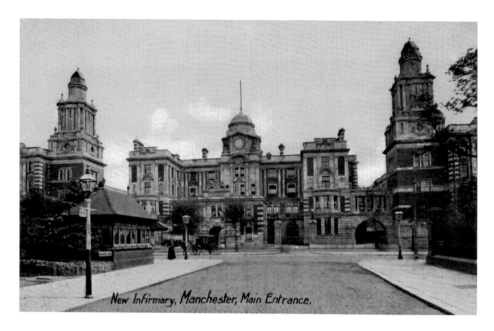

New Infirmary, Manchester, Main Entrance.

Manchester Royal Infirmary, Oxford Road, 1908

The new infirmary required the clearance of a large residential area, which was chosen because of its proximity to the medical education department at Owen's College. Students in the nineteenth century had previously been awarded degrees by the University of London. Streets around the old infirmary were cramped, and a nearby fire showed hospital staff how potentially dangerous evacuation procedures would be if the same occurred on their premises; they relocated in 1908. The 'asylum' had already removed to Cheadle, Cheshire, in 1849.

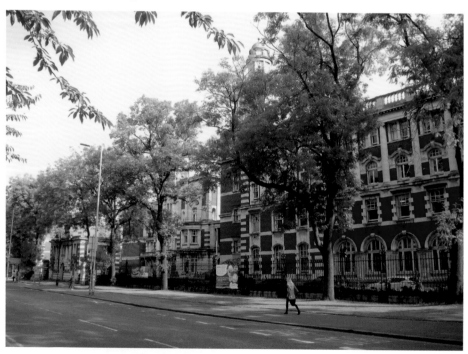

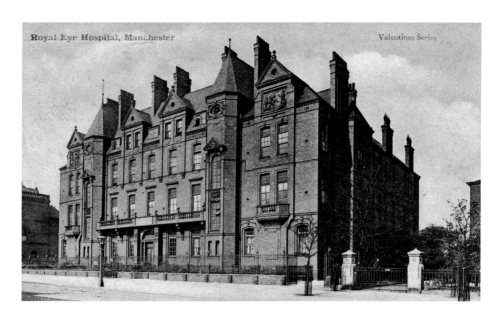

Royal Eye Hospital, Oxford Road, 1900

The eye hospital was founded as early as 1814, but the building on Oxford Road was constructed in 1884 and designed by Pennington & Bridgen. This was the first of a complex of hospitals constructed along Oxford Road that included St Mary's Hospital – the red-brick and terracotta building at the junction of Oxford Road and Hathersage Road (*inset*), 1909, and Manchester Royal Infirmary in 1908. A new hospital complex has now been constructed and continues to develop. This can be seen behind the original façade on Oxford Road.

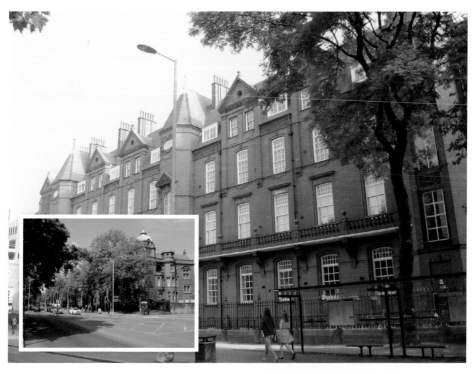

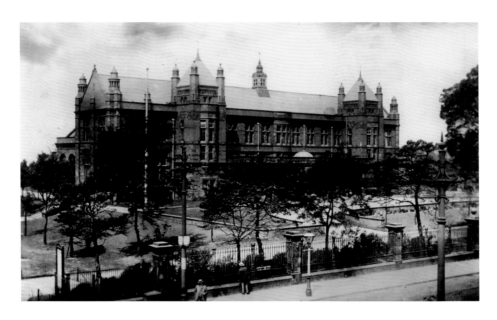

Whitworth Institute (Art Gallery), Oxford Road, 1908

Whitworth Institute was founded by Robert Darbishire in 1889 and built in 1894–1908 when the concept of Victorian philanthropy was at its peak. It was originally a voluntary cultural, technical and educational institution built in memory of one of the North West's great industrialists, Sir Joseph Whitworth. Manchester, as the world's first industrial city, now became an important cultural centre. Eminent figures became governors, including C. P. Scott who was editor of the *Manchester Guardian*. It also developed close links with Owens College – later a university after 1904.

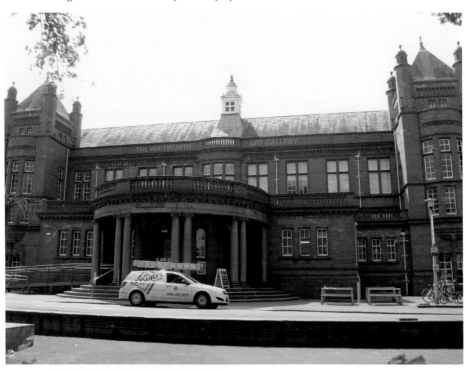

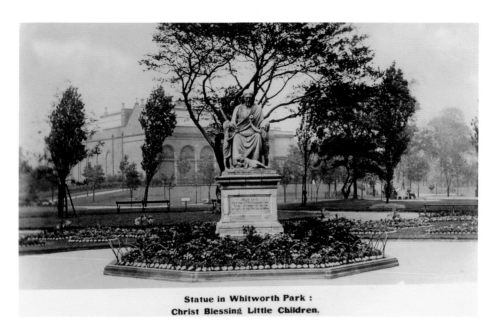

Statue in Whitworth Park :
Christ Blessing Little Children.

Whitworth Park and Institute (Art Gallery), Oxford Road, 1908

The Institute purchased Grove House, converting it into an exhibition hall in 1894–1908 (now undergoing a £15 million redevelopment) and Potter's Field, which became Whitworth Park. The 20-acre site, purchased in 1887, founded in 1889 and opened in 1890, was leased to the Corporation of Manchester by the Whitworth Trustees in October 1904 for 1,000 years, with a nominal annual rent of £10. The boating lake, bandstand, flower beds and statue of *Christ Blessing the Little Children* by George Tinworth (1904) have now gone.

Sources

Creighton, J., *Portrait of Manchester* (Wilmslow: Sigma Leisure, 1988)

Hartwell, C., *Pevsner Architectural Guides: Manchester* (London: Yale University Press, 2002)

Hayes, C., Francis Frith's *Around Manchester* (Salisbury: Frith Book Co., 2000)

Hayes, C., *The Changing Face of Manchester* (Derby: Breedon, 2001)

Langton, R., 'Cathedral Restorations', *Manchester Guardian,* 30 April 1874, p. 6

Langton, R., 'Notes on Church Restoration', *Transactions of the LCAS.* Vol. IV 1886
 (Manchester: A. Ireland & Co., 1887) pp. 50–60

Robert Langton's Scrapbook (1885) – Chetham's Library

Published Books and Ephemera (www.chethams.org.uk)

Workmen Start on Cenotaph Relocation. *Manchester Evening News,* 25 January 2014
 (www.manchestereveningnews.co.uk)

About the Author

Steven Dickens is the author of *Sale Through Time, Flixton, Urmston & Davyhulme Through Time* and *Stretford & Old Trafford Through Time.* He lives in Flixton with his wife, Sarah, and their three sons and three daughters. Living and working in Trafford for most of his life has allowed Steven time to pursue his interest in the local history of the area. He now turns his attention to the city of Manchester – the subject of this book.